Drawing in Color

FLOWERS & NATURE

Lee Hammond

NORTH LIGHT BOOKS
CINCINNATI, OHIO
www.nlbooks.com

Acknowledgments

For every accomplishment a person makes, there are numerous people who helped make it possible. In every new adventure we pursue or new task we attempt, our inspiration and desire are usually due to someone else.

It is for this reason that acknowledgments are so important. When I reflect on the past year or so, my life has changed dramatically. I've accomplished more than I ever thought possible, and have aspired to do even more. My list of things to do and try continues to grow.

But, the most notable aspects of my life are the people I have in it. I have come to realize the importance of family and friends more than ever before as a result of some serious losses.

I want to thank my mother for being such a wonderful example of grace under adversity. Her ability to cope with life's uncertainty, in such a calm and positive manner, is an inspiration to me. It is her strength that guides me and keeps me going.

I would like to thank my own family for being so supportive during such stressful times. This year I was able to spend time with many of my family members, which is the most important thing in the world. The most meaningful lesson I could ever teach, and the most vital thing a person could learn, is to take the time for people you love.

Drawing in Color: Flowers & Nature. Copyright © 2000 by Lee Hammond. Manufactured in China. All rights reserved. No part of this book may be reproduced in any form or by any electronic or mechanical means including information storage and retrieval systems without permission in writing from the publisher, except by a reviewer, who may quote brief passages in a review. Published by North Light Books, an imprint of F&W Publications, Inc., 1507 Dana Avenue, Cincinnati, Ohio, 45207. First edition.

05 04 03 02 01 5 4 3 2 1

Library of Congress Cataloging in Publication Data

Hammond, Lee, 1957
 Flowers & nature / Lee Hammond—1st ed. p. cm.—(Drawing in color)
 Includes index.
 ISBN 1-58180-037-1 (pbk.)
 1. Flowers in art. 2. Trees in art. 3. Colored pencil drawing—Technique.
 I. Title: Flowers and Nature. II. Title. III. Series
NC805 .H36 2000
743'.7--dc21 00-055045

Editors: James Markle/Nancy Pfister Lytle
Designer: Wendy Dunning
Production artist: Joni DeLuca
Production coordinator: Mark Griffin

This book is dedicated to my mother, Mrs. Dorothy Hagen.
Your strength is an inspiration to me. Thank you for being a wonderful mom,
with such unconditional love and understanding.

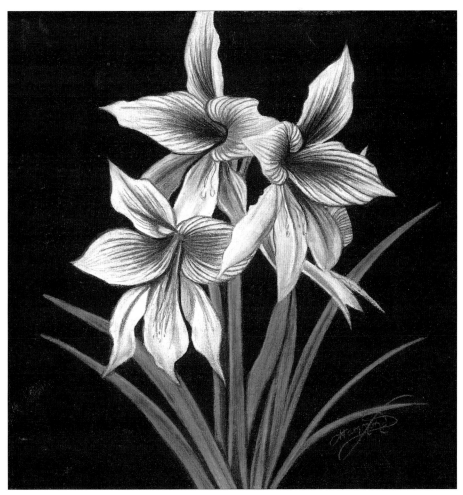

For Marlys Mohamed, a very special person in my life.
Knowing you has made my world a better place.

AMARYLLIS
Prismacolor on no. 1008 Ivory mat board
8" x 10" (20cm x 25cm)

About the Author

Polly "Lee" Hammond is an illustrator and art instructor from the Kansas City area. She owns and operates the Midwest School of Illustration and Fine Art, Inc., in Lenexa, Kansas, where she teaches realistic drawing and painting techniques.

She was raised and educated in Lincoln, Nebraska, and developed her career in illustration and teaching in Kansas City. Although she has lived all over the country, she will always consider Kansas City home.

Lee has been an author with North Light Books since 1994. She has written articles for other publications, such as *The Artist's Magazine* and *Kansas City Sports Magazine*.

Lee is continuing to develop new art instruction books for North Light and is also expanding into children's books, which she will also illustrate. Recently married to Sam Mohamed, she is sharing his love of motor sports and beginning a new aspect of her career by illustrating various types of racing. Limited edition prints of celebrity racing figures will soon be offered.

Lee is the mother of three children, Shelly, LeAnne and Christopher. She has two grandchildren, Taylor and Caitlynn.

Table of Contents

Introduction

This is an exciting book for me because it is the first opportunity for me to publish another aspect of my artwork, my photography. It has opened up a whole new direction for me as an artist. For this I must thank my sister, Barbara Hagen, for her inspiration. Her photography career is what made me want to try it.

Because of this new artistic medium, I have found my drawings now have more meaning. I encourage all of you to try photography. To take photographs to use in your artwork is to create something truly original.

As an artist, photography also provides you with the opportunity to really study your subject matter. This is extremely important when drawing realistically. Photography helps give you the chance to carefully study the effects of light and shadow, as well as the properties of color.

To be an accomplished colored pencil artist, you will have to learn more than one technique. This book is designed to explore the characteristics of the various types of colored pencils, along with their different applications, techniques and possibilities.

I've tried, with this book, to explain these properties in an easy-to-follow format. Drawing in color is definitely more complicated than drawing in black and white, but it is worth the challenge every time. Let me take you through this process. Together, we can discover a whole new world of artistic possibilities.

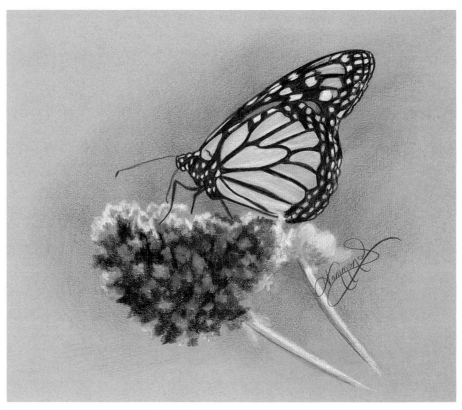

MONARCH BUTTERFLY ON LILACS
Prismacolor and Verithin on no. 909 English Rose mat board
8" x 10" (20cm x 25cm)

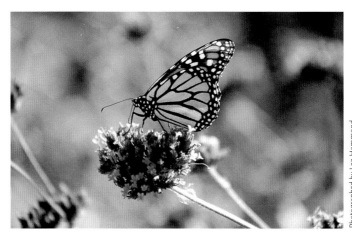

Photographed by Lee Hammond

Photo reference.

You Can Do It!

All accomplishments start with humble beginnings. As an instructor, I watch with amusement as students venture forth to try new things: I am always greeted with the predictable apprehension and the concern about being able to master a new technique. Of course, I know that they will be fine and will conquer the new medium—as well as their fear. But, everyone has their first tries . . . and perhaps their first failures, at something new.

Any time you try something new, it will take practice to figure out the best way to proceed. With art, unfortunately, our greatest lessons are in the mistakes we make. Rarely do our first attempts create the results we are striving for.

Don't be afraid to experiment. Even a professional artist such as myself must try new things and throw away the things that do not work. This is how we learn. Not all artwork is going to be "suitable for framing." However, the experiments are just as important as the final piece.

I didn't enjoy my first attempts at colored pencil. I had no one to demonstrate how it should be done, and, as much as I hate to admit it, in those days few books were written on this wonderful technique. After much frustration, I figured it out on my own and have grown to adore its versatility. How lucky you are to now have a large variety of instruction books to guide you.

These examples show the progress seen in a typical art student. The first attempt is not bad, but you can see the hesitance with which the student applied the pencil. This is normal, and with practice you will not be so afraid to lay in a heavier application of color. Because of the weak approach and the noticeable pencil lines, this piece looks unfinished.

The second example looks much different, doesn't it? The heavier application and the blending of the colors give it a much more finished appearance, as well as a more realistic look. The addition of the blue background makes the flower stand out. The end result is beautiful drawing and a good example of what can be done with colored pencil.

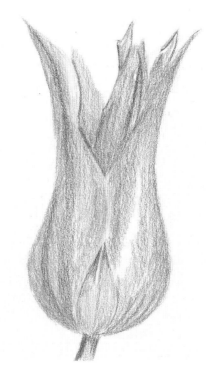

FIRST ATTEMPT IN PRISMACOLOR
Artwork by Kay Watkins.

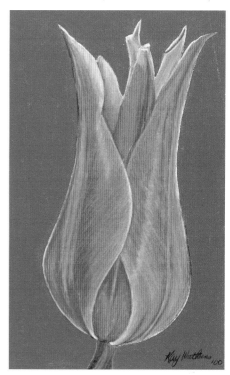

REVISED DRAWING IN PRISMACOLOR
Artwork by Kay Watkins.

Getting Started

Using the Proper Pencils

Each brand of colored pencil has a different appearance when used. Each pencil is made differently to create a different effect. When asked which pencil is "the best," or which one I like the most, I've been given a question that I can't answer easily. It really depends on the final outcome and the "look" I want my work to have. Rarely will I use just one brand of pencil to complete a project. Any one of them alone is somewhat limited. I have found that by using a combination of pencils, I can create more variety in my techniques. This enables me to achieve the look I'm trying to accomplish. The following is an overview of the six types of pencils I like the most.

PRISMACOLOR PENCILS

Prismacolor pencils have a thick, soft wax-based lead that provides a heavy application of color. They are opaque and will completely cover the paper surface. They are excellent for achieving smooth, shiny surfaces and brilliant colors. The colors can be easily blended together to produce an almost "painted" appearance to your work. They come in a huge selection of colors: 120 or more.

VERITHIN PENCILS

Verithins also have wax-based lead but have a harder, thinner lead than the Prismacolors. Because of their less

waxy consistency, they can be sharpened to a very fine point. They are compatible with Prismacolor but are more limited in their color range, which is thirty-six. I use Verithins whenever I want the paper to show through because they cannot build up

to a heavy coverage. They can give you very sharp, crisp lines. They are good for layering colors without the colors mixing together. The Prismacolors can give your work a painted appearance; the Verithins give your work more of a "drawn" look.

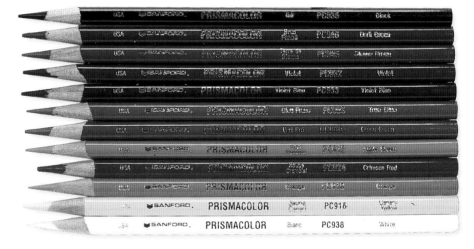

Prismacolor pencils.

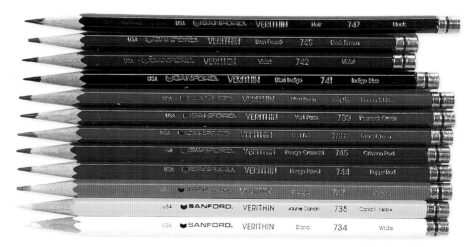

Verithin pencils.

COL-ERASE PENCILS

Unlike Prismacolor and Verithin, Col-erase pencils can be easily erased. They can also be blended with a stump or tortillion, giving it the look of pastel. Although these pencils have a limited palette of colors (only twenty-four), the ability to blend colors together makes them quite versatile. They also can be sharpened into a fine point, but due to their powdery consistency it is hard to achieve extreme darks. Left unsealed, without applying a fixative, they look like pastel. Spray them with fixative, and they can resemble watercolor.

STUDIO PENCILS

Studio pencils, by Derwent, is somewhat like a composite of the other brands. It is a clay-based pencil with a range of seventy-two colors. Applied heavily, it can create deep, dark hues. Applied lightly, it can be blended with a tortillion. It also has a sister pencil called the Artists line, which is the same formulation with a bigger lead diameter. I use the Studio line because I prefer a sharper point. Also, because it is clay based it will not build up color as well as Prismacolor and will give more of a matte (nonglossy) finish.

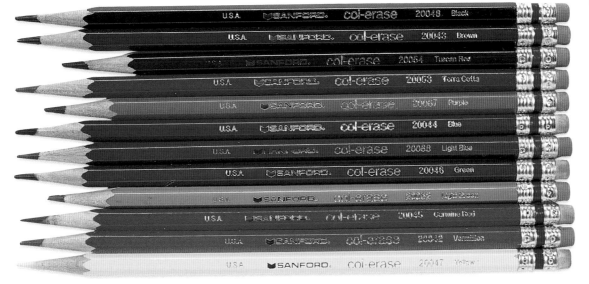

Col-erase pencils.

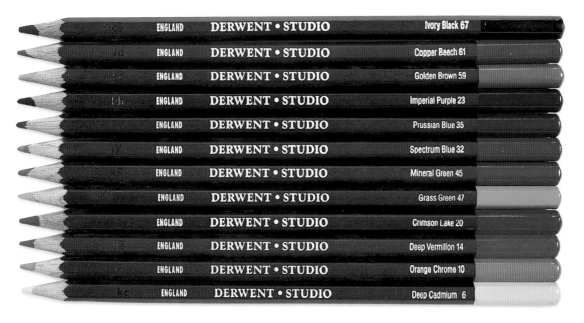

Studio pencils.

WATERCOLOR PENCILS

Watercolor pencils are a unique artistic tool that can be used to combine the techniques of drawing and painting. They contain actual watercolor pigment put into a pencil form. They can be used to draw with, just like any other colored pencil. But with the application of a little water and a paintbrush, the pigment dissolves into paint, changing the look entirely. These are a fun break from traditional colored pencils.

NEGRO PENCILS

Using the Negro clay-based black pencil is an excellent way to achieve deep, rich black in your work without a hazy wax buildup. This is the blackest pigment I've ever found in a colored pencil. It comes in five degrees of hardness, ranging from soft (1) to hard (5).

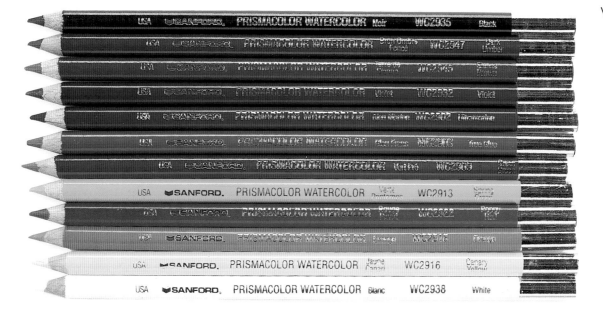

Watercolor pencils.

Negro pencils.

Tools of the Trade

As with anything we do, the quality of our work is determined by the quality of the tools we employ for the job. Artwork in colored pencil is no different. The following is a list of supplies you will need to succeed.

PAPER

The paper you use with colored pencils is critical to your success. There are many fine papers on the market today. You have the option of choosing from hundreds of sizes, colors and textures. As you try various types, you will undoubtedly develop your own personal favorites.

Before I will even try a paper for colored pencil, I always check the weight. Although there are many beautiful papers available, I feel many of them are just too thin to work with. I learned this the hard way, after doing a beautiful drawing of my daughter, only to have the paper buckle when I picked it up. The crease formed was permanent, and no amount of framing kept my eye from focusing on it first. From that point on, I never used a paper again that could easily bend when picked up. The more rigid, the better! Strathmore has many papers that I

Prismacolor on mat board.

Prismacolor on suede board.

Strathmore Renewal paper has soft colors with the look of tiny fibers in it.

Artagain, also by Strathmore, has a speckled appearance and deeper colors. Both have a smooth surface.

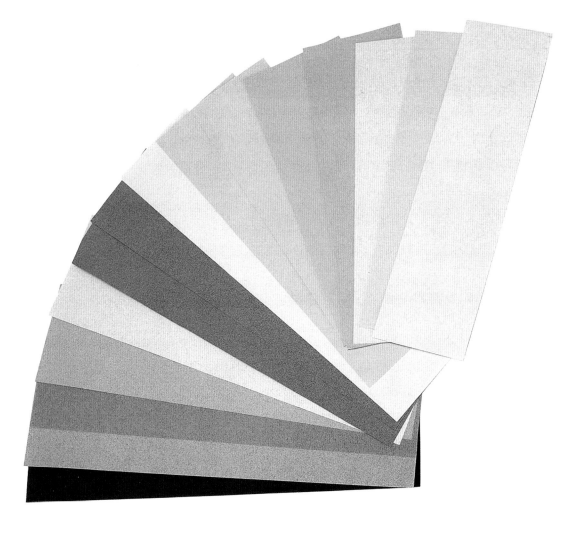

use often. The following is a list of the ones I personally like to use the most and recommend to my students.

Artagain—Artagain is a recycled paper by Strathmore that has somewhat of a flannel appearance to it. This 60-lb. (130gsm) cover-weight paper comes in a good variety of colors dusty as well as black and white. Although it has a speckled appearance, it has a smooth surface without any noticeable texture. It is available in both pads and single sheets for larger projects.

Renewal—Renewal is another Strathmore paper, very similar to Artagain, but it has the look of fibers in it instead of speckles. I like it for its soft earth tones.

Crescent Mat Board—My personal favorite is Crescent because of the firmness of the board. It is already rigid and doesn't have to be taped down to a drawing board. This makes it very easy to transport in a portfolio. Its wide range of colors and textures is extremely attractive. Not only do I match the color to the subject I am drawing, I will often use the same color of mat board when framing the piece to make it color coordinated.

Crescent Suede Board—Crescent Suede Board is another one of my favorites. It has a surface like suede or velveteen. I have developed a technique using Prismacolor that makes it look like pastel when applied to this fuzzy surface.

PENCIL SHARPENERS

Pencil sharpeners are very important with colored pencils. Later in the book, you will see how many of the techniques require a very sharp point at all times. I prefer an electric sharpener, or a battery operated one when traveling. A handheld sharpener requires a twisting motion of the arm. This is usually what breaks off the pencil points. The motor-driven sharpeners allow you to insert the pencil straight on, reducing breakage. If you still prefer a handheld sharpener, spend the extra money for a good metal one, with replacement blades.

ERASERS

I suggest that you have three different erasers to use with colored pencil: a kneaded eraser, a Pink Pearl eraser and a typewriter eraser. Although colored pencil is very difficult, if not impossible to completely erase (except for Col-erase), the erasers can be used to soften colors as you draw.

The kneaded eraser is like a squishy piece of rubber, good for removing your initial line drawing as you work. It is also good for lifting highlight areas when using the Col-erase pencils. (I'll show you later.) Because of its soft, pliable feel, it will not damage or rough up your paper surface.

The Pink Pearl eraser is a good eraser for general cleaning. I use it the most when I am cleaning large areas, such as backgrounds. It, too, is fairly easy on the paper surface.

The typewriter eraser looks like a pencil with a little brush on the end of it. It is a highly abrasive eraser, good for removing stubborn marks from the paper. It can also be used to get into tight places or to create clean edges. However, great care must be taken when using this eraser, because it can easily damage the paper and leave a hole.

MECHANICAL PENCIL

I always use a mechanical pencil for my initial line drawing. Because the lines are so light, unlike ordinary drawing pencils, they are easily removed with the kneaded eraser. As you work, replace the graphite lines with color.

TORTILLIONS

Tortillions are cones of spiral-wound paper. They are used to blend after you have applied the colored pencil to the paper. I use them only with Col-erase and Studio pencils. Prismacolor is much too waxy for this technique. Verithins work somewhat but don't blend as evenly as the clay-based pencils.

ACETATE GRAPHS

Acetate Graphs are overlays to place over your photo reference. They have a grid pattern on them that divides your picture into even increments, making it easier to draw accurately. I use them in both 1" (2cm) and ½" (1cm) divisions. They are easy to make by using a permanent marker on a report cover. You can also draw one on paper and have it copied to a transparency on a copy machine.

TEMPLATES

Templates are stencils that are used to obtain perfect circles in your drawing. I always use one when

drawing eyes to get the pupils and irises accurate.

MAGAZINES

The best source for drawing material is magazines. I tear out pictures of every subject and categorize them into different bins for easy reference. When you are learning to draw, magazines can provide a wealth of subject matter. When drawing people, there is nothing better than glamour magazines.

CRAFT KNIVES

Craft knives are not just for cutting things: They can actually be used as a drawing tool. When using Prismacolor, I use the edge of the knife to gently scrape away color to create texture such as hair or fur. It can also be used to remove unwanted specks that may appear in your work. As you can probably imagine, it is important to take care with this approach to avoid damaging the paper surface.

The Different "Looks" of Colored Pencils

Drawing in colored pencil is a somewhat deceptive term: It is not that simple. Each brand of pencil has its own unique look, produces a different effect and requires a different technique. There are many different types of colored pencils, each with its own formulation. When deciding which pencil to use, you must decide which look you want your artwork to have.

DECIDING WHICH PENCIL TO USE

When you begin a new project, you must ask yourself which pencil you need to create the look you are trying to achieve. Look at the examples of the nectarines and the peach. It is the technique and pencil used that distinguishes these fruits.

Another way I have varied the look of these drawings is the use of background treatments. Each one has a look all of its own. The soft use of color behind the peach replicates the softness of the peach itself. The intense black surrounding the nectarine makes the colors stand out more. The use of a simple shadow completes the watercolor example.

Throughout this book we will explore five different brands of pencils and the techniques that best utilize them.

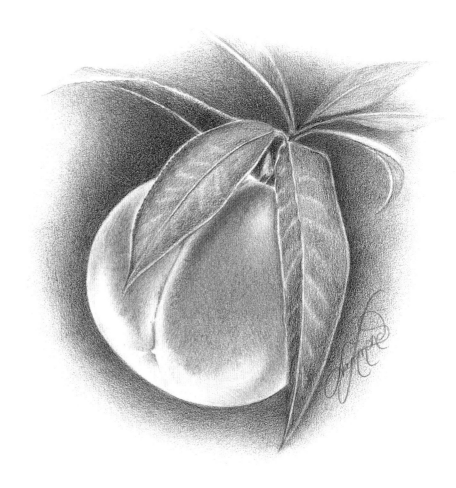

A PEACH DRAWN WITH VERITHIN PENCILS
To make the peach look fuzzy, I used Verithin pencils. The dry-looking layers that these pencils produce was perfect for creating the peach's fuzzy texture. Look at how the texture of the paper comes through to help create the overall look of the drawing.

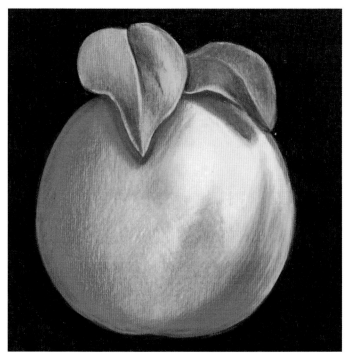

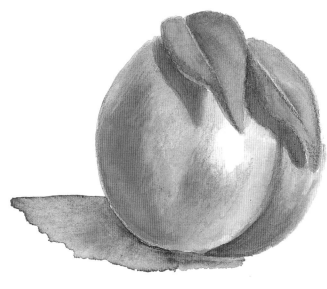

A NECTARINE DRAWN WITH PRISMACOLOR PENCILS
To capture the shine of a nectarine, I drew one using Prismacolor. Its ability to build up waxy, smooth layers of color was just right for creating the shiny skin of a nectarine. The opaque quality of these pencils makes drawing smooth, colorful surfaces possible.

A NECTARINE DRAWN WITH WATERCOLOR PENCILS
The second nectarine was drawn with watercolor pencils. It has a completely different look to it than the Prismacolor example. If I had wanted this to look more like a peach I could have used less water, which would have allowed more of the watercolor paper's surface to show through for texture.

Different Brands of Colored Pencils

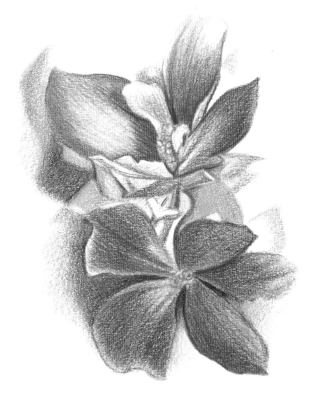

PRISMACOLOR
Pink flowers drawn with Prismacolor pencils. These pencils lay down thick layers of color that blend together for a smooth look.

VERITHIN
Pink flowers drawn with Verithin pencils. These pencils lay down light layers of color that show through one another, creating a grainy appearance.

> NOTE —
> Although all of these drawings may look alike at first glance, close observation will show unique differences between them due to the brands of pencils they were drawn with.

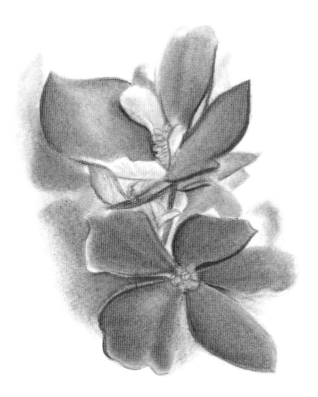

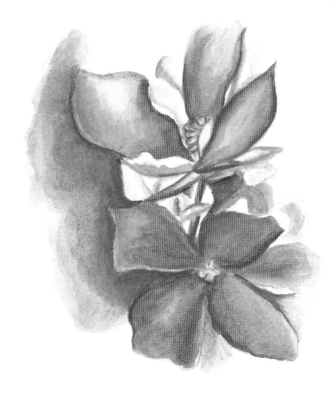

COL-ERASE

Pink flowers drawn with Col-erase pencils. These pencils create a soft pastel appearance when blended with a tortillion.

WATERCOLOR

Pink flowers drawn with Watercolor pencils. These pencils create the look of watercolor paintings when dampened with water.

STUDIO

Pink flowers drawn with Studio pencils. These pencils can be used heavy for complete paper coverage but can also be blended with a tortillion for smooth, gradual tones.

Technique

As with any technique, there is a right way and a wrong way to proceed. The most common complaint I hear about drawings made with colored pencil is that they can look like crayon drawings instead of a nice piece of art. This is just a misunderstanding of how the medium should be used. It is very important to learn how to apply the pencils properly.

The first example looks very much like crayon. The rough, uncontrolled fashion in which it has been applied looks childish.

The second example looks much better. The pencil lines have been applied smooth, so distinct lines are not evident. The result is a smooth gradation of tone from dark to light, with no choppiness. This type of control in application leads to good artwork.

A scribbled approach when applying colored pencil will produce a look similar to crayon.

Applying color using controlled pencil lines produces an even gradation of tone.

COLOR

A good understanding of colors and how they work is essential to drawing. It all begins with the *color wheel*, which illustrates how colors relate to one another.

The basic groups of colors are primary and secondary colors. Another is warm and cool colors. A third is complementary colors. Within these classifications you will encounter shades and tints.

There are three primary colors: red, yellow and blue. They are pure colors. Mixing these colors together in different combinations creates all the other colors. Mixing two primary colors together makes a secondary color. For instance, red mixed with yellow makes orange. Secondary colors can be found in between the primary colors on the color wheel.

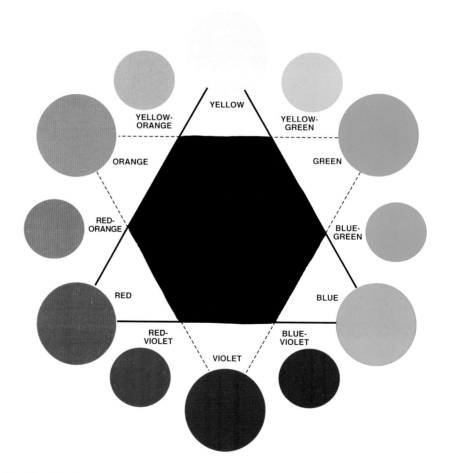

The color wheel.

Warm colors consist of the colors yellow, yellow-orange, orange, red-orange, red and red-violet. The cool colors are: violet, blue-violet, blue, blue-green, green and yellow-green.

Complementary colors are opposites on the color wheel. For example, red is the opposite of green. Opposite colors can be used in many ways. Mixed, complements become gray. It is always better to mix a color with its opposite for shadows rather than adding black.

An opposite color can also be used to "complement" a color, or make it stand out. For instance, to make the color red stand out, place green next to it. This is the most frequent color theory found when working with flowers and nature. Because almost all plants and leaves are green, and many flowers are red or pink, the flowers have a very natural way of standing out.

Shades and tints are also important. A shade is a darker version of itself. A tint, on the other hand, is a lighter version. Shades and tints are the result of light and shadow.

There are two more words that apply to color: hue and intensity. Hue is color applied lightly; intensity is color applied brightly. Unlike shades and tints, which have other colors changing the way they appear, hue and intensity apply to the overall concentration of color.

Experimenting with color is fascinating. As you proceed through this book, you will see many examples of using color creatively.

A value scale made with warm colors (red, orange and yellow).

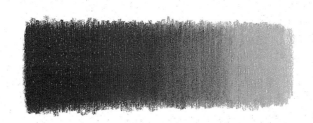

A value scale made with cool colors (violet, blue and green).

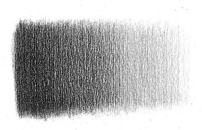

A value scale made with complementary (opposite) colors (blue and orange).

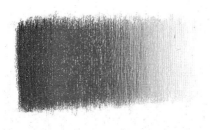

Shades and tints of red, as seen on a value scale. The middle section is the true color. Everything on the left is a shade. Everything on the right is a tint.

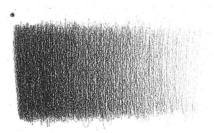

Greater intensity is achieved by increasing the hue.

The Five Elements of Shading

To create the illusion of dimension and form, there are important elements that *must* be incorporated into your work. This is why I begin all of my books with the same information: the five elements of shading and practice exercises of the sphere.

To draw a realistic-appearing ball resting on a table is to be able to draw anything more convincingly. It is the single most important thing you can teach yourself about drawing. Everything we draw requires these five elements for realism.

The elements are as follows (listed in order from darkest to lightest):

1. **Cast Shadow.** This is the darkest part of your drawing. It is underneath the sphere, where no light can reach. It gradually gets lighter as it moves away from the sphere.
2. **Shadow Edge.** This is where the sphere curves and the rounded surface moves away from the light area.
3. **Halftone Area.** This is the true color of the sphere, unaffected by either shadow or strong light. It is found between the shadow edge and full light area.
4. **Reflected Light.** This is the light edge seen along the rim of the sphere. This is the most important element to include in your drawing to illustrate the roundness of a surface.
5. **Full Light.** This is where the light is hitting the sphere at its strongest point.

Look at the drawing of the apple. Can you recognize all of the five elements in this piece?

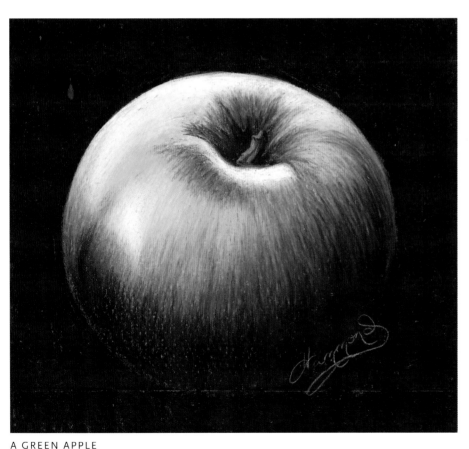

A GREEN APPLE
Prismacolor on no. 1008 Ivory mat board
8" x 10" (20cm x 25cm)
Sprayed with gloss damar varnish

> **NOTE —**
> This was drawn in shades and tints of green. When it was completed, I sprayed it with a clear varnish to make it look shiny. Study it closely for the five elements of shading. Notice the Terra Cotta and Tuscan Red used to complement the green of the apple.

> **COLORS USED**
>
> Apple Green, Black, Chartreuse, Dark Green, Parrot Green, Terra Cotta, True Green, Tuscan Red and White

Drawing Spheres Step by Step

Practice drawing many spheres, and commit these principles to memory. They will be the foundation that all of your artwork will be built on, not just for flowers and nature, but for every subject matter you attempt.

<table>
<tr><td>COLORS USED

Apple Green, Black, Canary Yellow, Dark Green and White</td></tr>
</table>

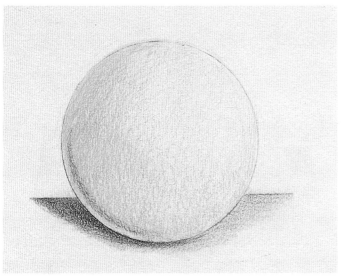

1 Begin your drawing of the sphere with a light outline of a circle. Place a cast shadow underneath, on the left side. This is opposite the light source, which will be on the right.

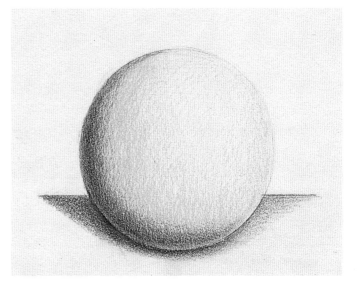

2 Apply the shadow edge inside and parallel to the rim of the sphere. Leave an area for the reflected light. Lightly continue the tone up toward the full-light area, lightening the color as you go.

3 Continue adding tone until the sphere looks like this. Smooth application of your pencil lines is essential for creating this look.

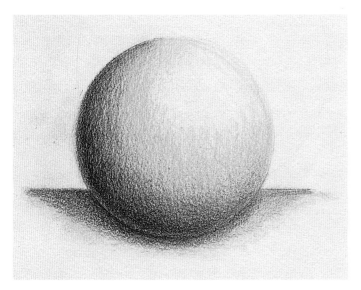

Drawing Cylinders Step by Step

Another important shape to practice is the cylinder. It, too, must contain all five elements of shading to look realistic. The shape of the cylinder can be seen in many of the subjects in nature. For instance, look at the shape of the apple stem in the illustration. These fruit stems are mini-cylinders, with the five elements of shading on them.

Think of some other things in nature that contain the shape of the cylinder. A good example would be a trunk of a tree, a branch or a limb. The stem of a flower is a cylinder also. You can see why it is so important to understand this shape.

Look around you and see how many things contain the shape of the sphere, as well as the cylinder.

The following exercises will give you some practice drawing cylinders. These have been drawn in yellow tones, using violet for the shadows. Draw your own cylinders and practice doing them in different color schemes. Experiment with warm and cool colors, like the value scales on page 19. Use the complement, or opposite color, for the shading.

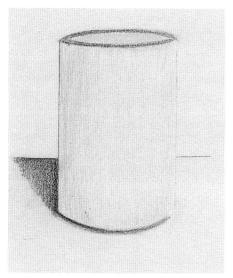

1 Begin your cylinder with a light pencil outline. Place a cast shadow underneath on the left side.

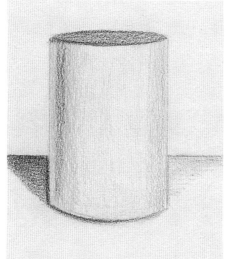

2 Add the shadow edge parallel to the edge of the cylinder. Leave room for the reflected-light area. On this tubular form, there will be two shadow edges. The one on the right, in the full-light area, will not be as noticeable.

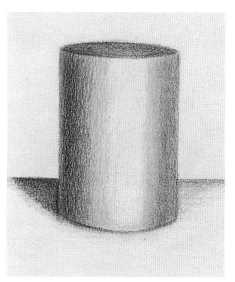

3 Continue adding tone until the cylinder looks like the one above. Draw slowly, gradually developing the tones.

NOTE —
The five elements of shading:
 Cast shadow
 Shadow edge
 Halftone Area
 Reflected light
 Full light

Study this drawing of an apple and a pear. Can you recognize the sphere shape in them? Look at the neck of the pear and the stem. These are both cylinders. Study the colors used in this piece. If you look closely, you will see that I have used complementary colors for the shading. The dark area of the apple was shaded with green (the opposite of red). The pear was shaded with violet (the opposite of yellow). This drawing was done with Verithin pencils. This is a good practice piece for you to try.

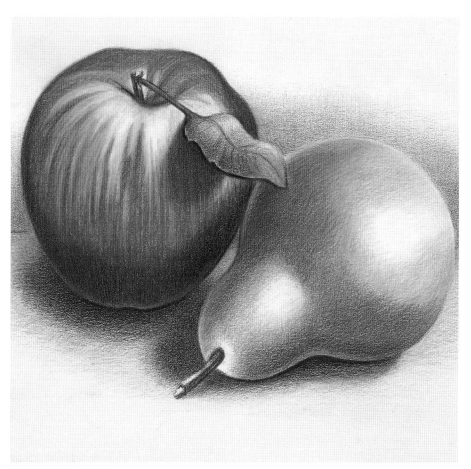

APPLE AND A PEAR
Verithin on no. 1008 Ivory mat board
8" x 10" (20cm x 25cm)

COLORS USED

Apple. Crimson Red, Canary Yellow, Dark Green, Poppy Red, Tuscan Red and White

Leaf. Dark Green, Olive Green, Peacock Green, and Tuscan Red

Pear. Canary Yellow, Grass Green, Lemon Yellow, Poppy Red, Tuscan Red, Violet and White

Background and shadow areas. Aquamarine, Peacock Green, Pumpkin Orange and Violet

Hard and Soft Edges

One more theory important to drawing flowers and nature is the use of hard and soft edges. We have already explored *soft edges* with the five elements of shading on the sphere and cylinder. A soft edge is found where something curves. The shadow edge of the sphere is a *soft edge*.

A *hard edge* can be seen wherever two surfaces touch or overlap. Looking at the drawing of the poinsettias, you will see many areas of overlapping shapes within the petals and leaves. Wherever two petals overlap one another, it creates a *hard edge*.

Reflected light and cast shadows are essential when drawing hard edges. This is what keeps the subject from looking "outlined." Any time you draw a hard edge, it is important to take the tone out, away from the edge, to prevent an outline appearance. Also, an edge of reflected light will place the tone "underneath," instead of appearing as an outline on the surface itself.

Anything that has an edge or a rim will have an edge of reflected light. It will clearly be seen where the edge overlaps a cast shadow area.

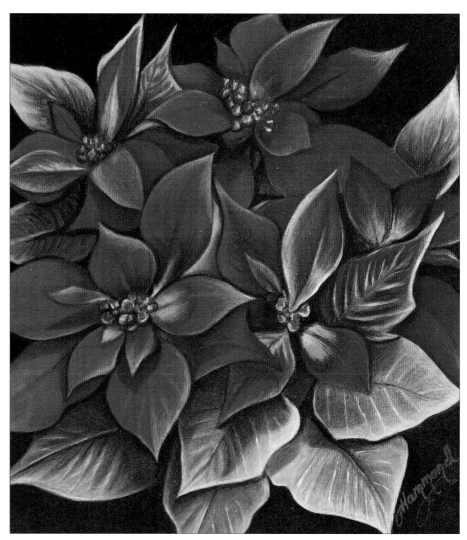

POINSETTIAS
Prismacolor on no. 1008 Ivory mat board
12" x 11" (30cm x 28cm)
Sprayed with satin tole finish spray

Drawing Poinsettia Leaves Step by Step

Let's draw poinsettia petals together to learn how to draw a hard edge. Also, look for the soft edge, where the petal gently curves. Without soft edges, the flower petals would look flat, like a sheet of paper.

1 Begin this exercise with a light outline of the petal's shape. Place a layer of Poppy Red down as a base color. Add some Black behind the petal for a shadow.

2 Add some Tuscan Red into the shadow area where the two petals overlap. Add some White to the edge of the petal to create reflected light.

3 Add Crimson Red to the petal with firm pressure, blending the colors together. Reapply both the Tuscan Red and the White. Use the lighter colors to soften into the darker ones to blend the colors together. This is called burnishing.

Graphing

To draw anything with a high level of realism, it is very important for the shapes to be accurate. Being able to see shapes accurately and translate them onto paper is not easy, however. While freehand drawing is often fun and enjoyable, it is rarely accurate—at least without investing a large amount of time in the process. There are some methods that will help you be truly accurate.

We will be working from photographs. The techniques learned here can then be used later when drawing from life. Working with photographs affords us many luxuries. It allows us time to really study the subject we are drawing, without fear of the position and lighting changing. It gives us the ability to edit the picture by enhancing certain elements while eliminating others altogether. But most important of all, it makes it possible for us to graph, or project, our beginning outline, giving us an accurate foundation to build our drawing on.

While some artists will argue that graphing or obtaining an outline with the use of an opaque projector is "cheating," I couldn't disagree more. I teach my students both methods as a means of training their eye to see

shapes accurately. Being self-taught, this is one of the ways I honed my skills. I attribute my ability to freehand with a high degree of accuracy today to using the graph and projector repeatedly early in my training. This repetition of capturing shapes and seeing how one shape connects to another measurably increases your ability to freehand accurately.

An opaque projector is a machine that uses a lightbulb to shine the image of a photograph down onto the surface of your drawing paper. Often, I will check a student's freehand ability with the projector. I take the photograph the student is drawing from and place it in

the projector. I then project the image *over* the freehand drawing. By lining it up, the same size, *over* the drawing, all of the inaccuracies show up. The students then can analyze where they went wrong and make the appropriate corrections.

The ability to see shapes is due to our "perception." It is how we "see" things. We often make the same mistakes over and over without even realizing it. The graph and the projector force us to see things a different way. This process makes us see things as just shapes alone. The graph helps you see the shapes accurately by dividing the image into smaller, more manageable shapes.

An empty graph of 1" (2cm) squares

> NOTE —
>
> To draw an image larger, make the squares on your drawing paper larger than 1" (2cm). You can reduce the size of something with this method also, by making the squares on your paper *smaller* than those on the photo. As long as the boxes are square, the shapes will be proportional.

Drawing From Graphed Photos—Iris

Look at the photograph of the iris. Let's look at it just as shapes.

To draw it accurately, I had the photo enlarged as a color copy. I was then able to draw a 1" (2cm) grid over the top of it. Because this photo had a dark background, I used a white pen for the dark areas and a black pen for the lighter ones. This is to help you see it more clearly. When you work from your own photos, you can place a transparent grid overlay over your picture rather than drawing on it. Or you can make a copy like I did and draw the grid on it with a marker. To draw from a graphed photo, you must first draw a graph on your drawing paper. This should be drawn very lightly with a mechanical pencil (the graph lines will need to be removed later). This graph is where you will draw the shapes of the iris as accurately as possible.

Draw the shapes you see within each square as close to size, placement and shape as you can. Go slowly and draw from *one box at a time*. Concentrate on seeing things as just "shapes." Forget that this is a flower. Turn your paper upside down to make the image less recognizable if it will help you see the shapes more accurately.

When you are finished, your line drawing will look like a simple outline of the major shapes. When you are satisfied with the shapes, take your kneaded eraser and remove the graph lines. This line drawing will be used to practice drawing with Verithin pencils later in the book. To see the final project, turn to page 36.

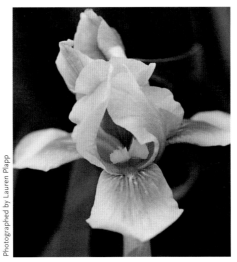

Photographed by Lauren Plapp

Photo reference.

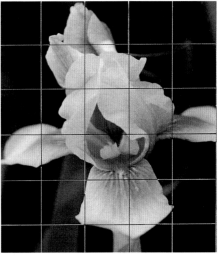

A GRAPHED PHOTOGRAPH
This is a color copy of the original photograph. I have applied a 1" (2cm) grid to use as a guide when drawing.

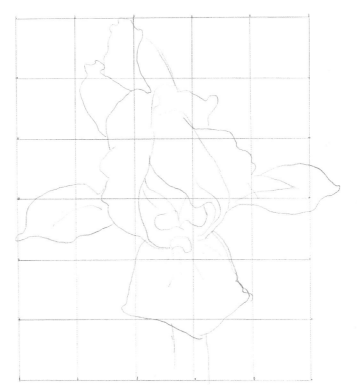

An accurate line drawing within 1" (2cm) squares.

Black-Eyed Susan

The following examples provide photographs already graphed for you to draw from. They will be good practice for you and most of them will be used later in the book as full-color step-by-step projects. Be sure to use the paper recommended, because it is important to the final look of the drawing.

Start by lightly drawing a grid of 1" (2cm) boxes on a piece of no. 8912 India mat board. The warm yellow color of the paper will play a very important part in creating the overall color of the flower.

Use the graphed photo as a guide and draw the shapes of the flower within each square as accurately as possible.

Your line drawing should look just like mine when you are finished.

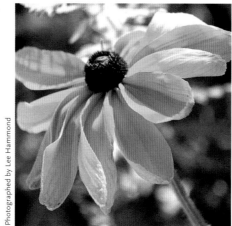

Photo reference.

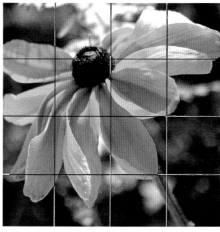

An enlarged copy of the photograph with a 1" (2cm) grid applied.

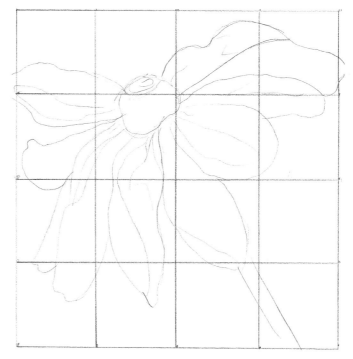

An accurate line drawing of the photograph.

Photographed by Lee Hammond

Pink Rose

This is a beautiful picture of a rose. I love the combination of colors, how they blend together and the stark contrast between the flower and the dark background. Because of its softness, we will use this for a drawing using the Col-erase pencils. This project can be found on page 48.

Look for the areas where the petals curl and the shadows that are created by them. These shadows should be looked at as shapes, also, and placed in your line drawing.

This project was drawn on no. 1030 Pastel Pink mat board. This color is useful for creating the soft pastel colors of the rose.

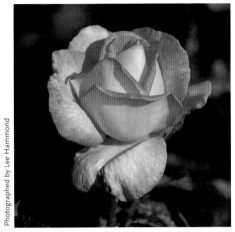

Photographed by Lee Hammond

Photo reference.

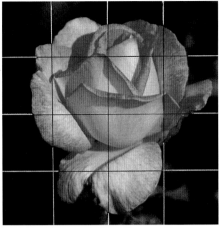

An enlarged copy of the rose with a 1" (2cm) grid applied.

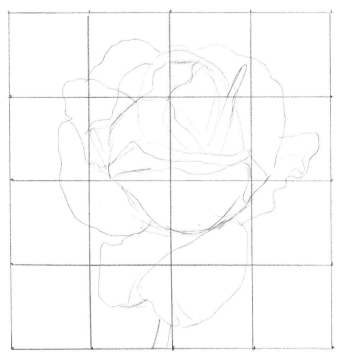

This accurate line drawing of the rose will be used for a project using Col-erase pencils on page 48.

Pink Coneflower

We will now use the same graphing procedure to draw the pink cone-flower in this photograph using Studio pencils. Use the same graphing procedure to create an accurate line drawing. This flower has many petals, all of which overlap. Be careful to draw these areas carefully by studying the shapes.

This project was drawn on no. 3343 Off-White mat board. This project can be found on page 47.

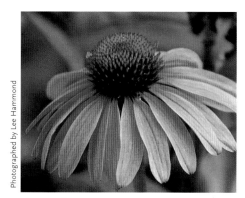

Photo reference.

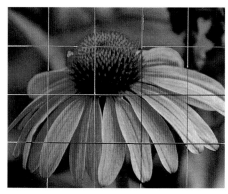

An enlarged copy of the flower with a 1" (2cm) graph applied.

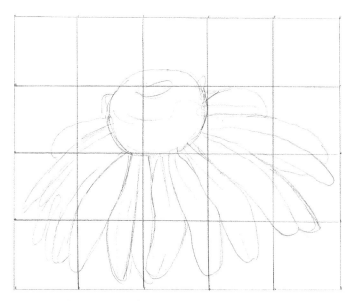

An accurate line drawing of the flower using Studio pencils.

Verithin Pencils

To begin drawing projects in color, I like to start my new students with Verithin pencils. They are a good introduction to using colored pencil and experimenting with color.

Verithin pencils have a dry, thin lead. They can be sharpened to a fine point, which is their most valuable characteristic. They come in a range of thirty-six colors. Be sure to have a quality pencil sharpener handy at all times. I recommend a battery-operated or electric style.

Examine the value scale. The colors layer without mixing together. The surface of the paper still shows through, creating a somewhat grainy effect. This is a wax-based pencil, but does not have enough wax in it to build up and completely cover the paper. I like Verithins for this reason. The layered approach looks very artistic to me.

This value scale of colors shows how the Verithin pencils layer. The colors do not build up and become heavy. The color of the paper shows through, creating a grainy effect.

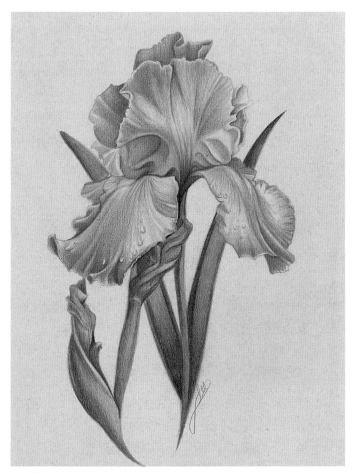

DRAWING OF AN IRIS
Verithin on Shell Renewal Paper by Strathmore
11" x 14" (28cm x 35cm)

COLORS USED

Flower. Canary Yellow, Carmine Red, Orange, Poppy Red, Rose and Tuscan Red
Leaves and stem. Apple Green, Dark Green, Olive Green, True Green and Tuscan Red
Stem casing. Pumpkin Orange and Yellow Ochre

NOTE —

The petals of this flower are very delicate, with many folds and creases. These recessed areas must be studied carefully for the dark shapes they create. They are especially obvious in areas where the petals overlap, creating hard edges.

The light shining on the flower creates these shadows. Look at the flower as a puzzle of interlocking light and dark shapes. These small patterns will help you develop the shape of the flower. Dark shapes help create lighter ones.

Look at the areas of reflected light along the edges of the petals. These help the flower look real and dimensional. The addition of the water droplet also adds to the realism. For a step-by-step example of drawing water drops, turn to page 77.

The following examples illustrate many looks Verithin pencils can create. From simple drawings to complicated subjects and backgrounds, they are a beautifully artistic way of drawing flowers and nature.

This drawing shows how even a shiny container can be rendered with this method. The gold look of the vase is merely patterns of colors, lights and darks. The "shape" of these patterns makes the gold look reflective and metallic.

This drawing is also a good example of complementary colors used for contrast. The pink and green work together well, but the most creative use of opposite colors is the way the yellow and violet tones are blended together. You can see this in the yellow petals of the poinsettia, where there are shadows and curves. Also, look at the violet color of the tabletop contrasting against, and reflecting up into, the color of the vase.

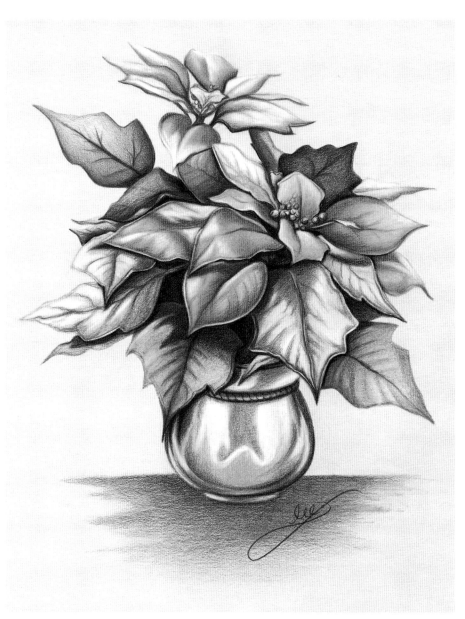

PINK POINSETTIAS IN GOLD POT
Verithin on no. 912 India mat board
11" x 14" (28cm x 35cm)

COLORS USED

Flowers. (Pink petals) Carmine Red, Dark Brown, Deco Pink, Tuscan Red and White; (Yellow petals) Lemon Yellow, Dark Brown, White and Yellow Ochre

Leaves. Apple Green, Canary Yellow, Dark Brown, Dark Green, Grass Green, Olive Green and Tuscan Red

Tabletop. Apple Green, Violet and Yellow Ochre

NOTE: *Look at the yellow petals and note how the colors of the leaves and flowers are reflecting down onto them.*

Backgrounds

These two examples are drawn in the same colors: The backgrounds are what set the two apart. This shows how different a drawing can look with the introduction of a background color.

The drawing of the hollyhock is a wonderful example of extreme light and dark. This is the type of lighting I like best for drawing and is what I try to achieve with my photography. Look at how the extreme dark green of the leaves makes the light, delicate colors

of the flower stand out. The grainy texture that the Verithin pencils provide helps illustrate the actual textures of the plant. I love the way the pencil lines in the petals help create the uneven surface of the flower.

This rose is a good example of overlapping shapes, hard edges and shadows. Each petal of the rose has all five elements of shading applied. The feel of bright sunshine is very obvious because of the strong full-light areas.

Because the edges of the flower petals are so light, I used a background color to make them stand out. Without it, there would be no way to define the edges of the petals without placing a line around them. Anything with an outline will appear flat. By doing it this way it looks like a light surface edge against a darker background. This is an important lesson: Always create "edges" instead of outlines.

This is an excellent example of the use of extreme contrasts of light and dark.

PINK HOLLYHOCK
Verithin on no. 1008 Ivory mat board
8" x 10" (20cm x 25cm)

COLORS USED

Flower. Carmine Red, Rose and Tuscan Red
Stems and leaves. Apple Green, Black, Dark Brown, Dark Green, Grass Green and Yellow Ochre

The addition of a background color helps create the light edges of the rose petals.

A PINK ROSE
Verithin on no. 1008 Ivory mat board
8" x 10" (20cm x 25cm)

COLORS USED

Flower and rosebud. Carmine Red, Crimson Red, Poppy Red, Rose, Tuscan Red and Yellow Ochre
Leaves and stem. Dark Green, Grass Green and Peacock Green
Background. Apple Green, Aquamarine and True Green

Using Texture, Color and Contrast

Color is one way of giving your art contrast. The use of light and dark is another. But there is still another way to create contrast, and that is the use of texture. In this drawing of a rose I have captured all three.

I love the look of brick and have used it many times as a background in my work. In this piece, the texture of the brick is a nice contrast to the soft petals of the rose. The shadows falling on the patterns of the brick create an interesting look. I increased the visual impact by letting the tones fade into an oval composition.

Once again, the color of the paper is important to your work. The yellow glow created by this mat board gives the entire drawing a warm, sunny feeling and makes the color of the rose beautiful.

COLORS USED

Rose. Canary Yellow, Carmine Red, Crimson Red, Poppy Red, Pumpkin Orange and Tuscan Red
Leaves and stems. Apple Green, Dark Green and Grass Green
Bricks. Black, Dark Brown, Dark Gray and Terra Cotta
Small flowers. Lavender, True Green and White

This is a nice example of contrasting textures and surfaces.

A ROSE ON THE HEARTH
Verithin on no. 971 Daffodil mat board
14" x 11" (35cm x 28cm)

Using Different-Colored Papers

Verithin pencils are not waxy enough to get bright, bold layers of color. But the paper you use underneath can enhance your colors. We've seen that in the previous examples. These two butterflies were both drawn with Verithin pencils but, due to the color of the background, they look entirely different.

This is what a butterfly can look like on lighter paper. I used the paper's gold tone to help create the colors of the wings. But, due to the bright white area where the sunlight hits, I had to do something to make the edges of the wings show up. Without a darker color next to them, they would have become lost in the color of the paper. I placed some darker colors behind the wings and gently let those colors fade into the background.

The use of creative color in the background illuminates the sunlit butterfly.

BUTTERFLY IN THE SUN
Verithin on Gold acid-free paper
9" x 12" (23cm x 30cm)

COLORS USED

Butterfly. Black, Dark Brown, Indigo Blue, Poppy Red, White and Yellow Ochre,
Background. Indigo Blue and Poppy Red

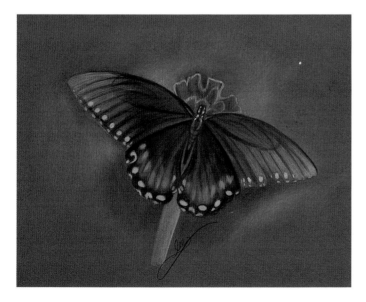

The light colors of the wings show up against the darkness of the paper.

BUTTERFLY ON A MARIGOLD
Verithin on Dark Gray acid free paper
9" x 12" (23cm x 30cm)

COLORS USED

Butterfly. Black, Dark Brown, Indigo Blue and White
Flower. Canary Yellow, Orange and Tuscan Red
Stem. Peacock Green, True Green and White
Background. Aquamarine, Grass Green, Indigo Blue, Magenta, True Green, White and Ultramarine Blue

Drawing With Verithin Pencils Step by Step

Let's try a project together using the Verithin pencils and the line drawing we did on page 27. This fairly simple drawing of an iris will give you a good introduction to using these pencils.

Examine the photograph once again. Look beyond the shapes to the colors of the flower. The base color of the iris is white. That's why I selected a white board to work on. Follow the instructions, step by step, to complete the drawing.

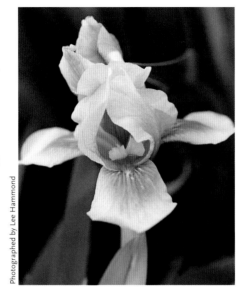

Photo reference.

Photographed by Lee Hammond

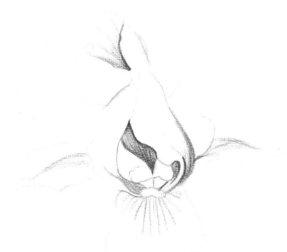

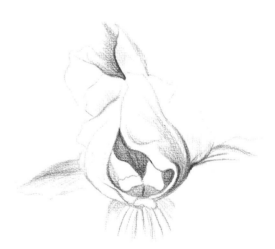

1 Use your line drawing from page 27. Begin placing Dahlia Purple into the dark areas of the flower. In the very center add some Tuscan Red on top of the Dahlia Purple.

2 Switch to Parma Violet, which is a lighter shade of purple. Continue adding tone to create the shapes of the petals. Add some Rose to the lighter petals.

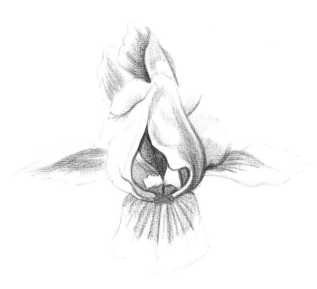

3 In this stage, add more Rose to the petals. Place some Canary Yellow to the far left petal and the center. Add Poppy Red to complete the center and also to the petal on the far right.

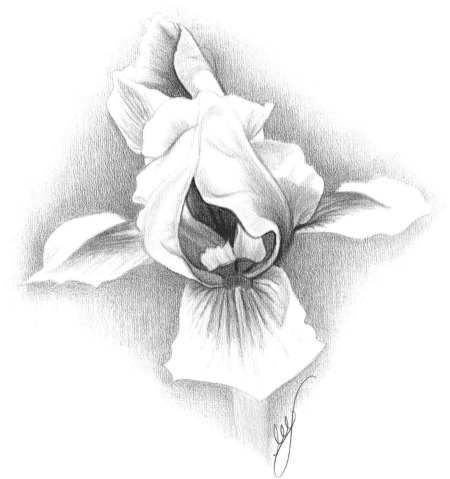

4 Add a smooth, even layer of Peacock Green behind the flower. This helps separate the white edges of the flower from the white background of the paper. Add a small amount of Apple Green to suggest the stem.

This concludes the introduction to Verithin pencils. For more practice, refer to seed catalogs and magazines for more beautiful pictures to draw from. The more you practice, the better you will become. Remember to draw all types of flowers in various colors. Experiment with different colors of paper to work on to see how this changes the look of the pencils. Most of all have fun!

Prismacolor Pencils

The previous chapter showed you how to achieve a soft, layered color with colored pencil by using Verithin. But what about capturing flowers that are brightly colored with shiny surfaces? A layered approach would not create those qualities.

I've mentioned before that not every pencil will create the look you need: It takes more than one type to be successful. For bright, vibrant color, the best pencil to use is Prismacolor. It has a wonderful range of 120 colors.

Prismacolor is a thick waxy pencil with a very rich, opaque pigment. The high wax content of this pencil allows the colors to blend easily and completely cover the surface of the paper. For this reason it can be used on any color of paper, even black.

The examples in this chapter show how realistic Prismacolor pencils can look. They could be confused with oil paints.

BURNISHING

Look at the value scale drawn with Prismacolor. If you compare it to the value scale from the previous chapter, you can see the differences between them. Unlike the Verithin example, the paper surface is completely covered, and the rich pigments blend together like paint. This technique is called *burnishing*. It is the process of taking a lighter color over the darker ones to blend and soften them.

USING DAMAR VARNISH

To make a drawing shine even more, making it resemble a painting, I spray it with a coating of gloss damar varnish (a varnish designed for oil paintings) when finished. Not only will this make your drawing look better, it will prevent the wax "bloom" that occurs with Prismacolor. This happens when the wax rises to the surface, making the drawing appear cloudy. Don't worry about this when you are working. Lightly buffing it with your finger or a tissue will make it disappear for a while, and spraying when you are finished will seal it permanently.

This value scale shows the heavily blended technique known as *burnishing*. The wax of the pencil allows the pigment to build up and blend together, resembling oil paints.

This value scale shows how the Verithin pencils layer. The colors do not build up. The color of the paper shows through the pencils.

Drawing a Lily on Checkerboard

This is an unusual approach to drawing a flower. I used this example in one of my art classes to discuss contrasts. By placing the checkerboard behind the flower you create visual contrast between graphic patterns and a realistic rendition. Since opposite colors complement one another, I placed Violet into the checkered background to enhance the yellow of the flower.

COLORS USED

Markers.
Canary Yellow and Black
Pencils.
Flower. Canary Yellow, Orange and Poppy Red
Stamen and pistils. Black, Burnt Sienna, Grass Green and White
Background. Black and Parma Violet

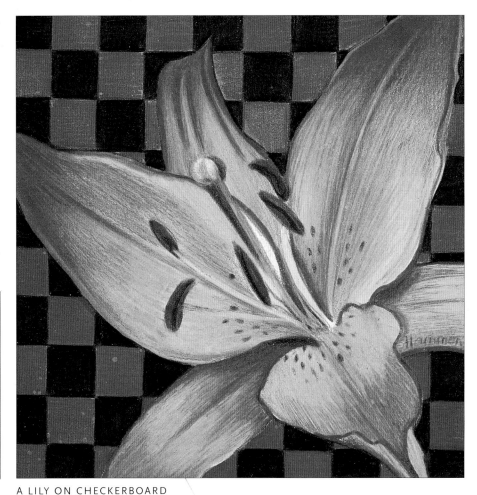

A LILY ON CHECKERBOARD
Prismacolor and marker on White bristol board
5" x 5" (13cm x 13cm)

Drawing a Red Poppy in Prismacolor Step by Step

Let's try another flower using Prisma-color pencils. Follow these easy step-by-step instructions to re-create this red poppy.

Photographed by Lee Hammond

Photo reference.

1 Using an enlarged copy of the photograph, draw lines to create your grid.

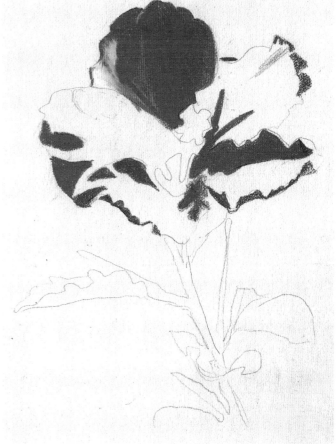

2 Study the photograph. Create a line drawing using the graphing method we learned in chapter five. Check your drawing once again for accuracy, and then we'll begin adding color.

3 Begin placing in the darker areas of the poppy with Scarlet Lake. Look at these areas as shapes. Study the completed petal on the top. Once the Scarlet Lake is applied, burnish over it with Poppy Red. The two blend together. Next add a white area of highlight.

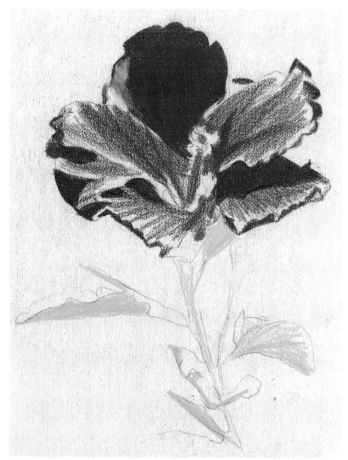

4 Proceed in the following manner with the rest of the petals. Apply the Carmine Red over the Scarlet Lake to fill in the color of the petals. Begin the stems and leaves by basing them in with Chartreuse.

5 This is what the petals should look like after applying pressure with the pencil and burnishing the colors together. To create the center, apply some Black.

COLORS USED

Petals and stamen. Black, Canary Yellow, Carmine Red, Poppy Red, Scarlet Lake and White
Stem and leaves. Chartreuse, Dark Brown, Dark Green, Grass Green and White
Background. True Blue (Verithin)

6 Continue with the stem and leaves by adding Dark Green over the Chartreuse. Also add Dark Brown to the stem.

To finish the poppy, add Canary Yellow to the top of the stamen. Then add more of the details into the leaves with Dark Green and Grass Green. Continue the details of the stem with Dark Brown. To complete the drawing, add more white highlights to the flower, leaves and stem, and bounce the Carmine Red into the stem areas. To create the gentle blue background, use a light application of True Blue Verithin and let it fade gently into the color of the paper.

Prismacolor is a wonderful way to create bold, realistic color. I urge you to look for references of brightly colored flowers and practice drawing as many of them as possible. You can use this method to re-create any image you see.

Blending with Col-Erase & Studio Pencils

When I teach my graphite techniques, I use a tortillion to gradually soften and blend out the tones. The result is a polished look with an extremely smooth transition of tones and no visible pencil lines (you can see this technique in my book *Drawing Lifelike Portraits from Photographs* and in the *Discover Drawing* series). This blending technique can also be applied to colored pencil by using Col-erase pencils by Sanford, or Studio pencils by Derwent.

Both the Studio and Col-erase pencils are clay based. For that reason, they look entirely different than Prismacolor or Verithin. The nonwax formulation of these pencils allows the pigment to be rubbed and blended together with a tortillion—a spiral-wound cone of paper designed to blend pencil, pastel and charcoal. Blending is the process of taking a tortillion to the pencil you have applied to the paper and rubbing it into a smooth, gradual tone.

The Studio line of pencils has a range of seventy-two colors. It is a heavier pencil than the Col-erase and can be applied darker and thicker. Its blend is not quite as smooth, as illustrated in the value scales.

Col-erase pencils have a range of only twenty-four colors, but because they can be blended, the ability to create colors is nice. They are also erasable (as evident by their name). This makes them good for "lifting" highlights and other details with an eraser.

It will be very important for you as a colored pencil artist to experiment and familiarize yourself with all of these techniques. Study various photographs of flowers and plants and ask yourself which pencil you feel would do the best job of capturing their individual characteristics.

Practice will be your key to success!

VALUE SCALES

Compare these value scales to the ones from the previous chapters, and you will see how different these pencils appear. Because of their ability to softly blend, they are excellent for drawing light-colored flowers.

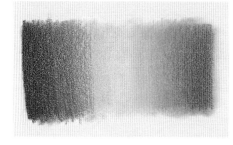

A value scale of Col-erase pencils (blended).

A value scale of Studio pencils (blended).

Blending With a Tortillion

This water lily is an example of Col-erase. This drawing was completed on White mat board using only four colors: Violet, Purple, Tuscan Red and Canary Yellow. All of the tones, with the exception of the center, have been blended out with a tortillion to make them gradual and smooth.

> **COLORS USED**
>
> Canary Yellow, Lavender, Magenta and Tuscan Red

A WATER LILY
Col-erase on no. 918 Very White mat board
8" x 10" (20cm x 25cm)

Spray Fixatives

These lilies are also an example of Col-erase. You can see the soft blend in the background. But for this drawing I changed the appearance of the pencil by spraying it with workable fixative when I was finished. Because these pencils have no wax in them, they are sensitive to the moisture of spraying. This will cause the colors to "melt," changing their look into an almost ink like appearance. Practice this before you apply it to a finished piece of art. The colors change dramatically, as seen in the example.

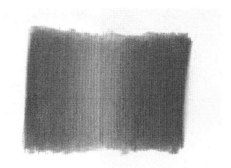

A color swatch of Col-erase. The section on the right has been sprayed with fixative; the section on the left has not. Look at how the colors have changed.

The pigment of the Col-erase pencils will "melt" when exposed to fixative. This example looks almost like an ink wash in areas. Unless you want your colors to change and deepen like this, leave Col-erase drawings unsprayed.

AUTUMN-COLORED LILIES
Col-erase on Ivory acid-free paper by Fiskars
9" x 12" (23cm x 30cm)

COLORS USED

Flower. Brown, Canary Yellow, Orange and Vermilion
Background. Indigo Blue, Light Blue and Magenta

Drawing a Coneflower Step by Step

Using the line drawing from page 30, let's try a project using the Studio pencils. Study the photograph and follow the step-by-step instructions to completing the coneflower.

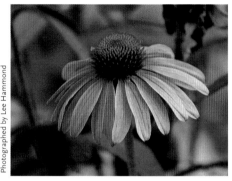

Photo reference.

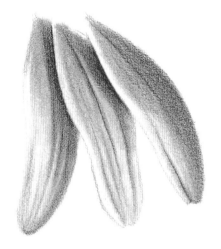

Look at the overlapping surfaces, edges, cast shadows and reflected light in this enlargement of the petals.

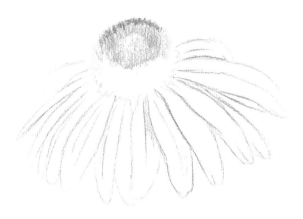

1 Replace the graphite lines with Magenta. Begin the center with Spectrum Orange.

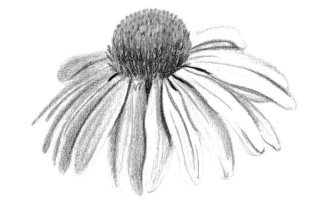

2 Add Deep Vermilion to the petals on the left side. Begin the color and texture of the center with Deep Vermilion, Naples Yellow and Black.

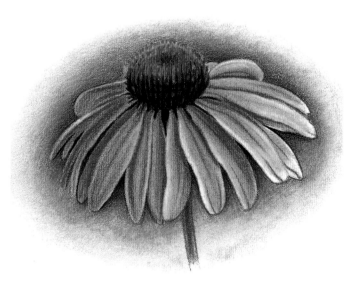

3 Add Bottle Green and Cedar Green behind the flower for a background. Soften the tones with a tortillion. Studio will not blend as smooth as Col-erase and will still appear a bit grainy.

Drawing a Pink Rose Step by Step

This pink rose is another example of the very smooth tones created with the Col-erase pencils. Many of the white highlights of the petals were lifted from the paper with a kneaded eraser. The veins of the leaves were erased with the point of a typewriter eraser.

Refer to page 29 for the photograph of the pink and yellow rose. Follow these step-by-step instructions to complete the project using Col-erase pencils. I used no. 3315 Porcelain mat board for the drawing surface.

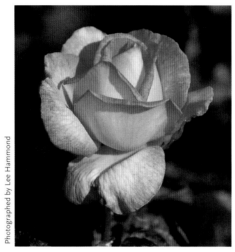

Photographed by Lee Hammond

Photo reference.

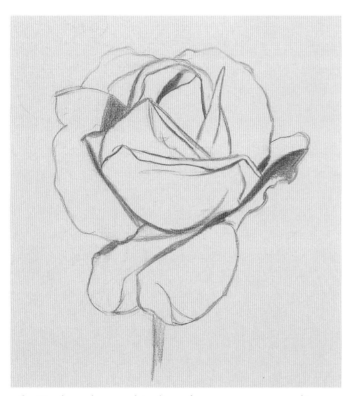

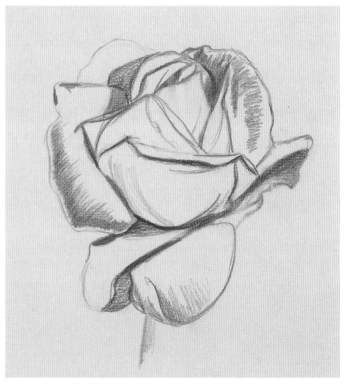

1 Replace the graphite lines from your accurate line drawing with Carmine Red Col-erase. This will prevent the gray of the graphite from blending in and dulling your color.

2 Fill in shadow shapes with Tuscan Red and Carmine Red. Begin placing color in the front petal with Rose.

COLORS USED

Tuscan Red, Pink, Rose, Canary Yellow, Green and Dark Brown

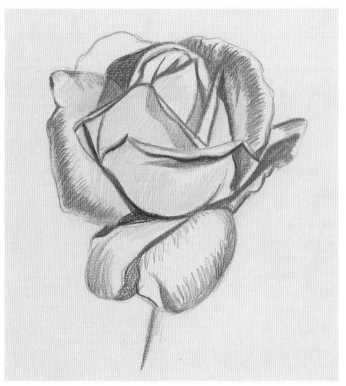

3 Add Canary Yellow to the drawing.

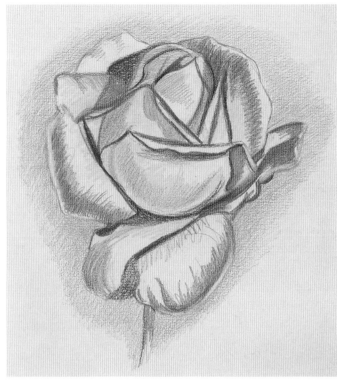

4 Apply Green around the rose for a background color.

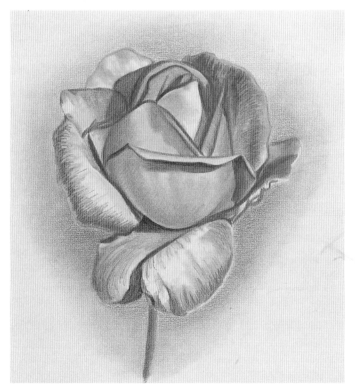

5 This is the finished rose after all of the colors have been blended with a tortillion. It has a beautifully soft impression.

NOTE —
It is not necessary to push very hard on tortillions to blend the colors. Pushing too hard will collapse the tip and rough up the paper surface. A light, soft touch is all that is required for a smooth blend of tone with Col-erase.

This drawing has not been sprayed. It has a much softer look.

Watercolor Pencils

There certainly is more to colored pencil than meets the eye. There are so many different looks that can be captured. But who would have ever thought that you could create a *painting* with colored pencil? You can with watercolor pencils.

Actually, watercolor pencils have been around for the last thirty-five years. They just weren't very popular in the fine art community. They were marketed more for schoolkids, for mapmaking and such. But now they have taken the art field by storm.

There are quite a few brands on the market today, and all of them are very good. For this book and my own personal use, I have used both Derwent and Prismacolor. I think Prismacolor is my favorite brand.

Watercolor pencils are just what the name implies: pencils with the lead made of actual watercolor pigment. Drawn on paper, they look like ordinary colored pencils and actually feel a lot like the Studio pencils. They can be used dry, like regular colored pencils. But with the addition of a little water and a damp paintbrush, magic can occur, turning your drawing into a beautiful watercolor painting.

WATERCOLOR VALUE SCALE

The value scales on top are drawn with watercolor pencil. They look very much like those of any other colored pencil.

The bottom illustrations show what the value scales look like with the addition of water. When drawn lightly, the wash produced is very transparent and fluid. Now look at the difference when the colors are drawn dark in the dry stage: They become even darker when wet. Keep this in mind in the drawing stage so things don't get out of control when you add the water.

These value scales have been applied in dry form. The one on the left is a light layer of pigment; the one on the right has been applied heavily.

The same value scales with the addition of water. The one on the left, which was applied lightly, now looks like a light wash. The one on the right, with more pigment, now looks more like opaque paint.

Using Watercolor Pencils

This is an example of a watercolor pencil drawing/painting. Study it closely and you can see where part of it looks drawn while the other looks painted. It is a nice combination of techniques that results in a unique appearance.

> **Note —**
> This is a combination of drawing and painting. Some areas look drawn and very controlled; while others look like they have been painted with a paintbrush.
>
> Look closely at the glass vase. All of the colors above it are reflected into its surface. The bright highlight areas streaking across the colors were "lifted" with a typewriter eraser after the artwork was completely dry.
>
> The background was created with a technique called borrowing. This is where you take pigment from the tip of your pencil with a wet brush, and then paint it onto your paper.

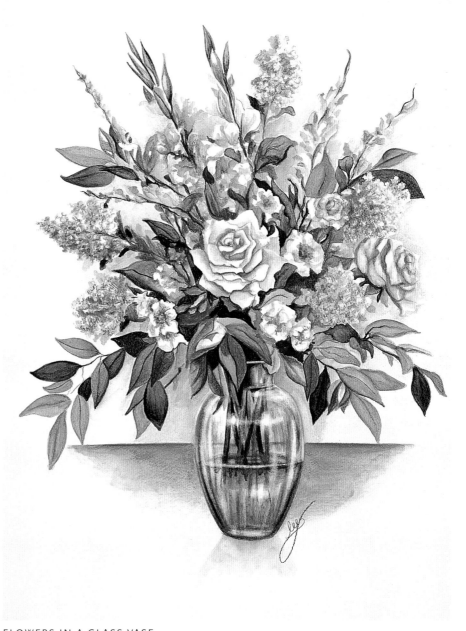

FLOWERS IN A GLASS VASE
Watercolor pencils on watercolor board
20" x 16" (51cm x 41cm)

Watercolor Paper

It is very important to use a paper made for watercolor when using these pencils. Although mat board can be used if you aren't planning to use much water, it is a paper made of plies. These plies can separate when wet, making it warp and buckle. I recommend you use a good watercolor paper or watercolor board.

To further illustrate the look that watercolor pencils can create, I have drawn the same picture two ways. The first drawing of the columbine is drawn with the watercolor pencils dry. The picture is beautiful like this in its dry form.

The second example is what it looks like using the wet approach. It has a looser, more impressionistic appearance and looks more like a painting than a drawing.

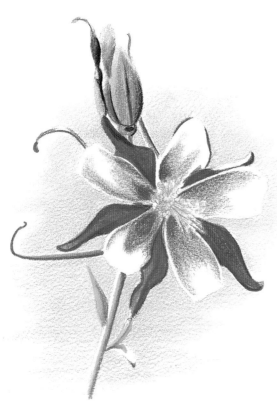

This drawing of a columbine has been left dry, like a traditional colored pencil drawing.

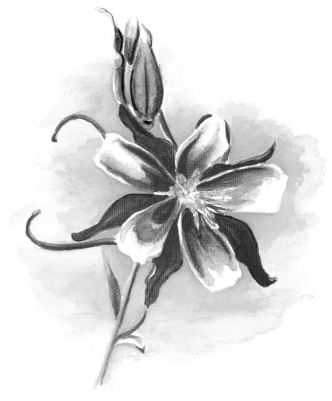

This is the same drawing with water applied. It looks like a watercolor painting now.

Examples of Watercolor Pencil Drawings

The following examples have been done with watercolor pencils. Each one of them has a unique look resulting from the technique applied.

This is an example of a simple drawing/painting using an uncompli- cated color scheme. The pure white background keeps the artwork look- ing clean and uncluttered. I like the way the water has made the edges of the flower look so crisp.

This is an example of a complementary color scheme (yellow and violet). The combination of drawing and painting gives it an interest- ing appearance.

YELLOW ROSE
Watercolor and Col-erase on watercolor paper
10" x 8" (25cm x 20cm)

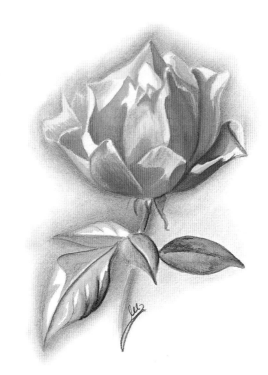

COLORS USED

Canary Yellow, Dark Umber, Grass Green, Orange, Poppy Red, Spring Green, Sunburst Yellow, Terra Cotta and Lavender

COLORS USED

Dark Purple, Olive Green and Spring Green

PURPLE WATERLILY
Watercolor pencils on watercolor board
10" x 15" (20cm x 25cm)

Watercolor Pencil Drawing Step by Step

This photograph of a flowering bush has all of the elements I like for this technique: It has areas of bright highlights, which the white of the paper can represent, and it also has extreme dark areas to make the highlights show up. The blurred background lends itself to a watercolor approach.

This project was drawn on a thick watercolor board by Strathmore. Its rigid surface can take any amount of water without warping.

Some artists feel that watercolor painting is "unforgiving," and that there is little control in its outcome. I do not agree and have devised many "tricks" for creating the look I want in my work.

Look closely at the finished example. I have used both a typewriter eraser and a craft knife to create the light textures of this wood. After your work is completely dry—I usually wait overnight—a typewriter eraser can easily lighten an area for you. It will lift some of the pigment off of the paper, and the point gives you the control you need. I used it to lighten the middle of the branch to create more roundness. I also used it to lighten any petals that lost their highlights in the washing process.

Can you see the small white dots of texture in the limb? I used the edge of a craft knife to scrape the pigment away. This is a wonderful technique for creating texture. Just be sure to approach it with a light touch to keep from gouging the paper.

Watercolor pencils are a fun deviation from traditional colored pencil techniques. I encourage you to play with them and see if you can develop a style all your own.

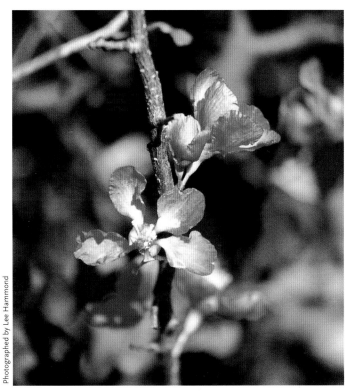

Photo reference.

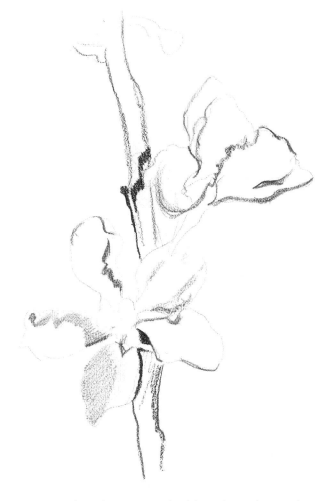

1 Create a line drawing and add Dark Umber and Crimson Red to it.

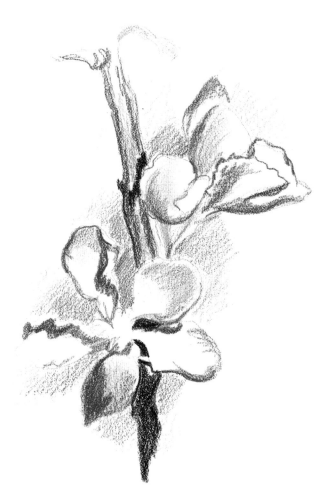

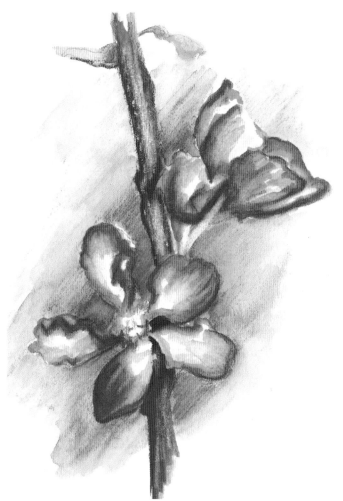

2 Increase the color of the branch with Terra Cotta. Add Carmine Red to the petals.

Create the background with diagonal lines of Dark Green and Grass Green.

3 Now for the fun part! Dip a pointed watercolor brush in a jar of clean water. Lightly paint over your drawing with the water, allowing the pigment on your paper to melt. You have to be careful at this stage and use some control in your shapes. You are still drawing here and creating shapes—not just blobbing on water. You may want to experiment on a separate piece of paper before completing this project. It is important to see how the pigment reacts to the water and what kind of stroke you will need. It is also important to maintain the edges of your drawing and not use so much water that it "bleeds" outside the lines.

This type of drawing usually has to be done in stages, allowing one section to dry completely before moving to the next. For instance, on this piece I finished the flower and branch and allowed it to dry before wetting down the background. This kept the two areas from bleeding together and maintained the crisp edges of the subject matter.

> NOTE —
> You can create textures of a drawing or painting by lifting them with a typewriter eraser or scratching them out with a craft knife. When using this method with a watercolor painting, be sure the paper surface is completely dry by waiting overnight.

Velour and Suede Papers

To me, there is nothing more beautiful than the look of soft realism. It is the effect I seek most when drawing or painting. Although I often try to vary the techniques and looks of my art, the soft, blended approach always calls me back.

This is an approach that is rather new. It is the process of using colored pencil on a fuzzy, flocked paper called velour, which is popular with pastel artists due to its soft, velvety surface. Its nap holds and retains the chalky nature of pastel and provides a very delicate look.

Suede board is similar to velour. It is actually a board used for cutting mats for framing. I saw it and decided to try it as a drawing surface. It is remarkable paper and is probably my favorite board for drawing on. The look is soft and makes flowers appear to be almost touchable.

This drawing was drawn on Whisper suede board. Its soft beige color is a good background for many types of subject matter. It worked wonderfully for this pink flower. The light color of the suede board helps create the light color of the flower.

The sharp contrast between the flower and the background is impressive.

VALUE SCALES
Compare the two value scales here. The first one shows what Prismacolor looks like when applied to regular mat board. The second shows what it looks like when applied to suede board. The difference is very noticeable. You must decide—before you begin your art—which one will give you the look you want to achieve.

This is what Prismacolor looks like when applied to regular mat board.

This is what Prismacolor looks like when applied to suede board.

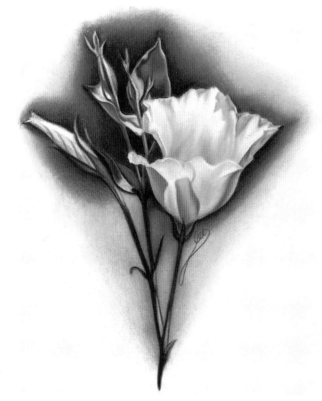

A STUDY IN PINK
Prismacolor on no. 7132 Whisper suede board
11" x 11" (28cm x 28cm)

Drawing on Velour or Suede Paper

Look at how smooth and soft the color is in this piece. The extreme contrasts between the dark and light areas is beautiful. This paper makes the colored pencil appear extremely soft. It requires a very light touch to master this technique. I find myself holding the pencil way back toward the end to keep the pressure off the tip. By holding the pencil less upright, you reduce the occurrence of pencil lines, allowing the pencil to gently fade out onto the paper like pastel. When you need a hard edge or line, a sharp pencil with firm pressure will work well. This paper does not interrupt the line quality and still allows you to achieve the sharp details you need.

Because of the sensitivity of this paper, I do not recommend spraying it with fixative when you are finished. Because the pigment of the colored pencil does not build up with this technique but is diffused across the surface of the paper, you will not see a wax bloom cloud your work. Spraying then becomes unnecessary.

One of the downsides to this paper is its ability to attract dust, lint and hairs. I have pets in my studio and am always having to check the paper for hairs. You can, however, lift up debris with a piece of tape without damaging your work. Always be sure you have cleaned up your drawing before placing it into a frame.

Even complicated subject matter looks great on this surface. For these lavender flowers I used white velour paper. I exaggerated the overlapping of the flowers by enhancing the shadows and giving them bright reflected light along their edges. It has a very dimensional look, and an almost abstract appearance.

FLOWERS IN LAVENDER
Prismacolor on White velour paper
6" x 10" (15cm x 25cm)

COLORS USED

Dark Green, Dark Purple, Deco Aqua, Hot Pink, Indigo Blue, Mulberry, Process Red and White

Drawing With Prismacolor on Velour Paper

Often when I'm looking at photographs to work from, I'll spot one that is just perfect for suede or velour. When I saw this photo, I knew immediately it would be perfect!

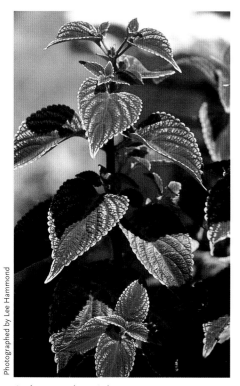

A photograph in red tones.

NOTE —
The red tones of this plant matched the color of the paper perfectly. Having it show through in the drawing perfectly replicated the color of the leaves. By adding green in the background as a complement, the plant really jumps out.

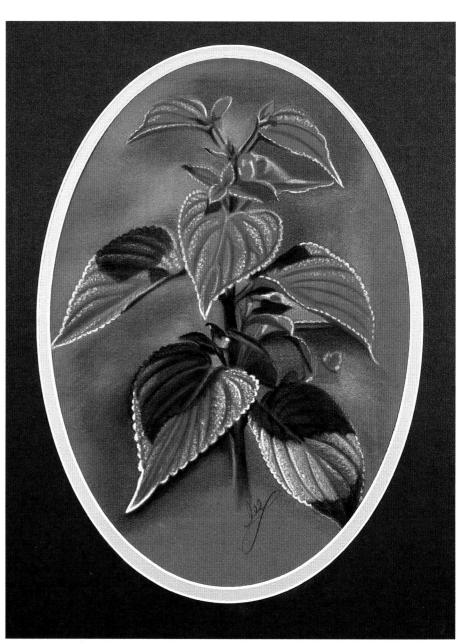

A STUDY IN RED
Prismacolor on Red velour paper
9" x 12" (23cm x 30cm)

COLORS USED

Flower. Black, Bronze, Henna, Hot Pink, Mahogany Red, Tuscan Red and White
Background. Aquamarine, Dark Green, Peacock Green and White

Using Watercolor Pencils on Velour Paper

This is an example of something extremely unique. Although I always use Prismacolor pencils on velour, I wanted to try something new. A manufacturer of the velour paper was interested in seeing how its paper performed using watercolor techniques. The manufacturer mounted the paper to a board to keep it from warping under the effects of moisture and then asked me to experiment with it.

The results were interesting. I explored both traditional watercolor paints and watercolor pencils to see how they would react on a flocked surface. I came up with this bouquet of roses. I love the effect.

I do *not* recommend this technique for newcomers to watercolor. It does not perform like anything I have ever experienced before. The paper surface absorbs the water immediately, making it difficult to manipulate the watercolor pencil that has been drawn. When applying traditional paint or "borrowing" color, the pigment soaks in and stays there. But despite all that, once you get the feel—and get used to the hard-edged look it produces—it is rather fun to work with. It just takes some getting used to.

You can see areas where the water melted the pigment so completely that you see no pencil lines at all. In areas where I used less water, such as in the stems, the lines remain crisp.

To keep the background smooth and gradual, I resorted to traditional watercolor so I could apply a large area of color with a lot of water. The result was a unique-looking piece of art with a very definite creative flair.

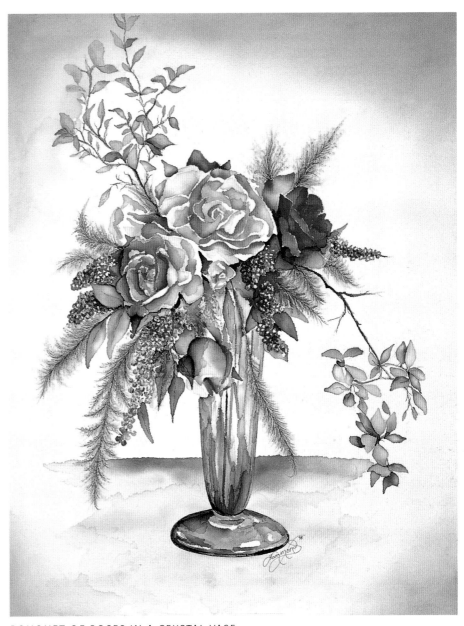

BOUQUET OF ROSES IN A CRYSTAL VASE
Watercolor and watercolor pencils on mounted White velour paper
20" x 16" (51cm x 40cm)

Drawing on Suede Paper Step by Step

This is an example of how I would attempt a detailed drawing on suede board. To purchase this board for your own projects, check with your local frame shop. Most of them either have it in stock or can order it from their framing suppliers.

The softness of the bee and the background made me select this photograph for a project on suede board. For this drawing I chose a white board. The surface of this paper has a "swirled" quality. Because of this, you wouldn't necessarily have to draw in a background (but it would look pretty plain without one). I like the suede board because of this characteristic, while velour paper has an even surface.

This has become one of my favorite techniques; and it can be used for a variety of subject matter. To see it used in portrait drawing, refer to my book *Drawing in Color: People and Portraits*.

I hope you will try this fun, interesting approach to colored pencil.

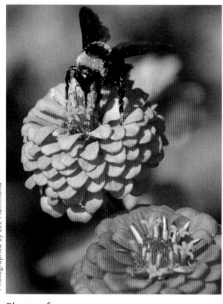

Photo reference.

1 You cannot graph on velour or suede paper because you cannot erase. Use a projector or transfer paper to obtain your line drawing.

Begin the drawing by replacing projected lines with Magenta. Begin filling in the shadow shapes with Process Red and Magenta. Use Canary Yellow to begin the center and bee.

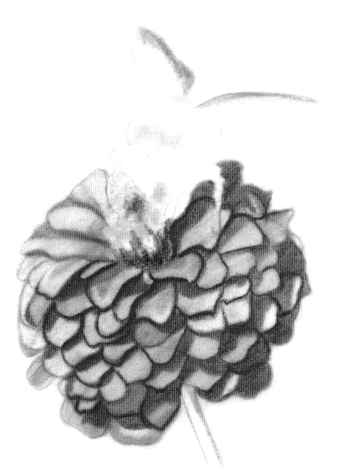

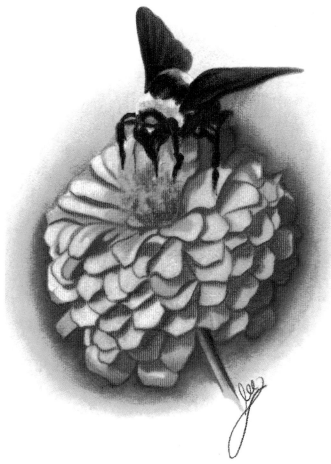

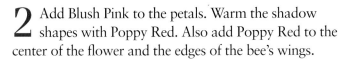

2 Add Blush Pink to the petals. Warm the shadow shapes with Poppy Red. Also add Poppy Red to the center of the flower and the edges of the bee's wings.

3 Create the background using a combination of blended green tones. Apply the black to the wings and body of the bee and add Burnt Ochre to the tips of the wings. Add the black last to keep it from smearing into the colors and dulling them. Create the stem using Apple Green and Black.

Leaves and Plants

Drawing and photographing flowers is one of my favorite things to do. No other subject matter seems to have the myriad of colors, shapes and varieties so readily available to the artist. Being that they are mostly outside and subject to the effects of light, the extreme highlights and shadows make them appear differently every time you look at them.

Flowers lend themselves to almost every type of art. It is no wonder they can be seen throughout history in the art of every culture. Flowers are portrayed realistically and abstractly. They are found in drawings, paintings, clothing, jewelry, sculpture, stained glass, mosaics and more. The possibilities are endless for you.

But there is more to this artwork than just flowers. To truly be able to draw nature, you must also learn to draw the other things that grow with flowers, such as leaves and ancillary plants. Drawing leaves presents just as much of a challenge as the flowers themselves. Some leaves are just as colorful.

Always look for the lighting when doing photography or artwork. I've mentioned the Old Masters in my other books, and this theory from them is my credo: "Draw not just the subject but the effects of *light* on the subject."

SHADOWS

This drawing looks pretty simple. But I think that sometimes the simple ones are just as nice. This little plant sitting in the sun created a very cute composition. Actually it was not the plant but the *shadow* of the plant that captured my eye.

Study the shadow. Look at how the lighting affects its color. As the shadow goes farther back, it takes on a warm look with the addition of Terra Cotta, which was placed into the outside edge.



COLORS USED

Leaves. Apple Green, Dark Green and True Green

Stem. Apple Green, Canary Yellow and Terra Cotta

White Prismacolor was used for the highlights on the leaves and stem.

Foreground shadows. Black and Dark Brown

Background shadows. Black and Terra Cotta



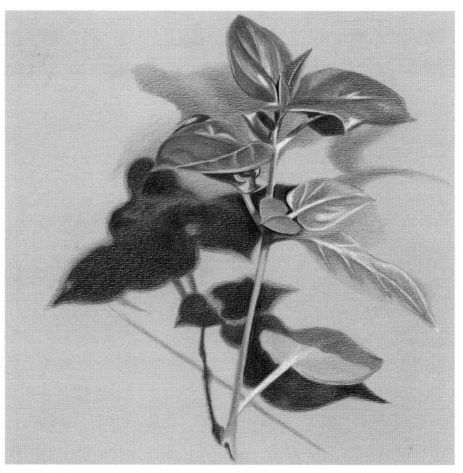

THE SHADOW
Verithin on no. 1026 Rose Gray mat board
8" x 10" (20cm x 25cm)

Leaf Details

These two photographs are a good study of leaves and what to look for when drawing them. Each is from a different view, allowing you to see different elements.

The *front view* of a leaf has bright sunshine washing across the surface. Look closely at the veins of the leaf and how the light makes the recessed areas appear dark. Each vein is seen clearly. Study the edges of the leaf. Look at the light edge of reflected light standing out against the dark background. Remember: Everything with an edge, lip or rim will have reflected light running along that edge.

The photo on the right shows the *back side* of the leaf. Notice how everything that was recessed on the front view is now a raised surface. Look at the veins and how they now appear light against the darker surface of the leaf.

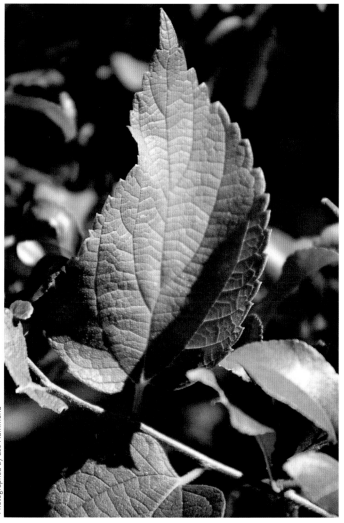

The front side of a leaf. The veins appear recessed into the surface.

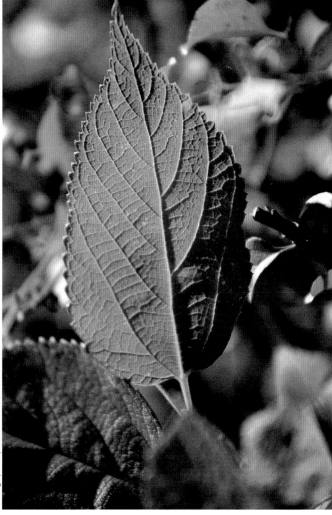

The back side of a leaf. The veins are now seen as a raised surface.

Drawing Basic Leaves

To give you some practice drawing leaves, let's draw one of the leaves from this photo of a limb. This has a wonderful lighting situation that creates beautiful areas of light and shade.

The Prismacolor pencils did a great job of capturing the details. The use of a marbleized paper for a background gave it the illusion of being seen against the sky.

Use this photo to practice drawing a leaf and berry.

Using marbleized paper gives the illusion of the sky in the background.

LIMB AND BERRIES
Prismacolor on Blue Marble paper by Strathmore
14" x 11" (35cm x 28cm)

Drawing Special Leaves

The following illustrations show some very different approaches to drawing leaves. Each one has its own special quality and characteristics created by the type of pencil used to create it.

Since Col-erase pencils cannot be used for deep, dark hues, I used the Studio pencils on the second study. They are good for blending darker colors. This illustration of leaves is a perfect example. The dark, rich tones at the end of the leaves were captured perfectly with the Studio pencils. The lack of background color makes this drawing seem uncluttered and fresh.

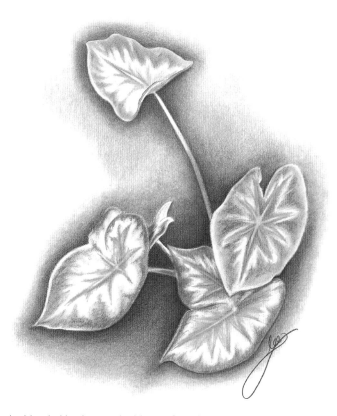

The blended background adds a soft quality to this drawing.

MY HOUSEPLANT
Col-erase on no. 3297 Arctic White mat board
10" x 8" (25cm x 20cm)

> **COLORS USED**
>
> **Plant.** Green, Light Green and Magenta
> **Background.** Brown, Lavender and Orange

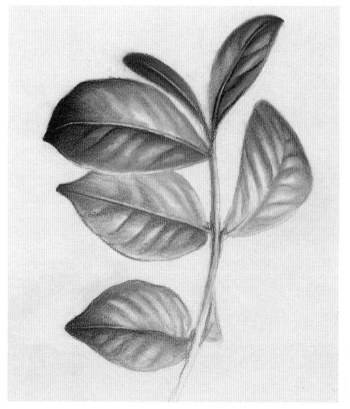

These colors were softened with a tortillion. The light areas are the color of the paper coming through.

A STUDY OF LEAVES
Studio on no. 1014 Olde Grey mat board
10" x 8" (25cm x 20cm)

> **COLORS USED**
>
> Bottle Green, Burnt Carmine, Grass Green, Ivory Black and Mineral Green

Drawing a Leaf and Berry Step by Step

Follow the step-by-step instructions for drawing this leaf and the cute little berry.

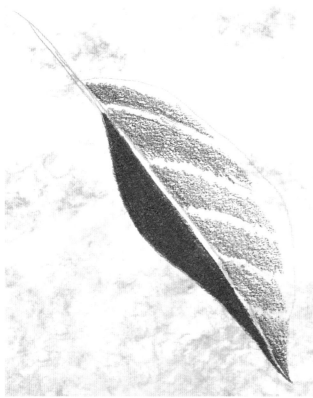

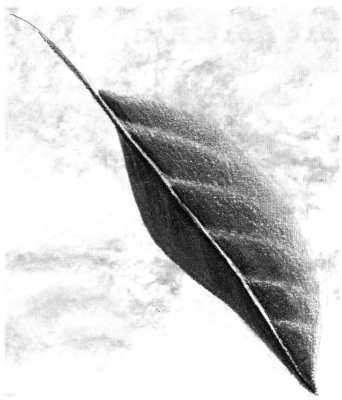

1 Begin with a light pencil outline of the leaf. With Olive Green, completely fill in the leaf to the left of the center vein. Lightly apply the Olive Green to the right side, creating the pattern of the veins. Leave the edge of the leaf empty.

2 Apply Tuscan Red to the left side of the center vein and up the stem. This complementary color will darken the Olive Green. Apply a light layer of Limepeel to the light edge of the leaf, overlapping the Olive Green and the vein areas.

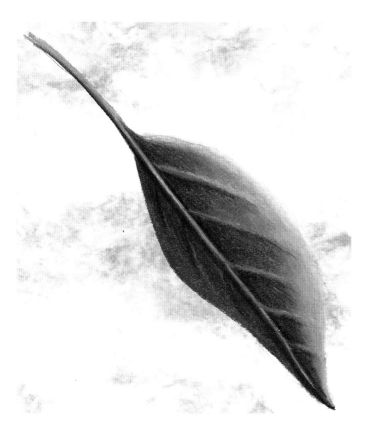

3 Apply Sand to the center vein and burnish it into the colors on the right side of the leaf. This will blend the tones together. Apply some White and burnish it into the right side of the leaf. Finish with a small amount of Black, emphasize the edges of the veins.

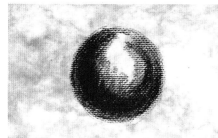

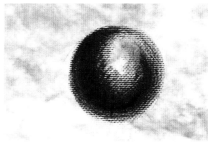

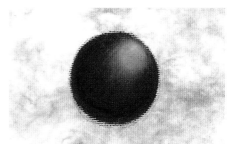

1 To draw the berry, begin with an outline of a circle. Apply a light application of Henna to begin the overall color. With firm pressure, apply Tuscan Red to create the shadow edge.

2 Add Black to the shadow edge to enhance the roundness.

3 Burnish over the berry with Henna to blend the tones. Apply Henna to the outer edge of the left side. For the reflected light, apply White to the full light area for a highlight. To transition the White and keep the berry from looking too pink, burnish Sunburst Yellow into the Henna. This gives the berry a warm glow of color.

When you are finished with both the leaf and the berry, the drawing should be sprayed with a varnish or fixative to prevent the pigment from "blooming" (the waxy haze associated with Prismacolor).

Trees

We have been concentrating on what nature looks like up close. But that is not the way we always see things. For instance, in the previous chapter we learned how to see and draw the details of a leaf. But what about see-ing and drawing the whole tree! The details are no longer seen, and we must approach the drawing in an entirely different way.

Whenever I draw trees, I look at them through squinted eyes. This blurs the impression, making the tones of light and dark more intense and obvious. It also makes the tones look more like interlocking shapes. The patterns created are what you should replicate in your drawing. It will make the trees look airy and nat-ural, without looking too filled in. Resist the habit of making the same shapes over and over again. This will look unreal. Each grouping of leaves should look unique in its shape and appearance.

> **Note—**
>
> I used Blue Marble paper again to give the illu-sion of the sky. I used a Black Prismacolor pen-cil for the entire drawing.
>
> Look at the technique I used for rendering this tree. First I sketched some of the branches and limbs. A sharp pencil is very important here to keep the pencil lines thin and tapered.
>
> Second, I began adding groups of leaves. I used small, irregular circular marks, holding my pencil somewhat on the side.
>
> I continued adding circular marks. I filled in some areas and left others empty allowing the sky to come through.

SILHOUETTE OF A TREE
Black Prismacolor on Blue Marble paper by Strathmore
14" x 11" (35cm x 28cm)

Drawing Trees

Look at the drawing of the tree on the previous page. It has thousands of leaves—but none of what we learned about drawing leaves will apply. To draw these we must see them not as individual leaves but more as abstract patterns of light and dark.

COLORS USED

Black, Canary Yellow, Dark Green, Indigo Blue, Poppy Red, Scarlet Red and White

NOTE —

I drew the trees around this windmill much the same way as for the previous drawing, only this time I used color. I used Prismacolor pencils to make the colors seem bright and vivid.

Each grouping of foliage had a different color. These colors overlap one another, creating patterns. I used the same type of flat, circular pencil marks to create this tree.

With the point of a very sharp black pencil, I added the small limbs, being sure they disappeared in and out of the foliage.

WINDMILL BEHIND THE TREES
Prismacolor on no. 972 French Blue mat board
8" x 10" (20cm x 25cm)

Drawing Tree Bark

Tree bark can be a fun challenge. This tree with the squirrel had an extremely rough surface. However, it didn't have much color. I used a Black Verithin to capture the detail of the tree bark. I used dark pencil lines for the recessed areas and lighter ones for the texture. The squirrel was drawn with Terra Cotta and Black. I used an extremely sharp point to make his fur look soft.

For using only three colors, the drawing still has a very realistic look.

The tree with the bird's nest, on the other hand, has a very smooth surface. The tubular shapes of the branches remind me of the cylinder exercise from page 22. Look for the five elements of shading when drawing shapes like these. Can you see the reflected light and shadow edges on each of the limbs? Because of those elements, these branches look very rounded and dimensional.

This drawing was also done in Verithin pencils using only three colors: Terra Cotta, Dark Brown and Black. All of the light areas are where I left the color of the paper coming through. The small light areas of the bird nest were erased with a typewriter eraser.

A realistic drawing can be created with very few colors.

GROUND SQUIRREL
Verithin on no. 1008 Ivory mat board
10" x 8" (25cm x 20cm)

Look for the cylinder and the five elements of shading in this drawing.

THE BIRD'S NEST
Verithin on no. 912 India mat board
10" x 8" (25cm x 20cm)

Drawing Texture

This photograph of the knothole is another excellent example of the interesting colors and textures you can find in nature. I just had to draw it! This photograph has some extreme lighting coming from the left. Because of the dark background, the light side of the tree really shows up.

To create the texture of the tree bark, I used loose, layered vertical lines using Verithin pencils. The inside of the knothole was drawn with brown circular strokes. I then placed some vertical black strokes *over* them to look like wood grain.

Squint your eyes when you look at the photograph. Can you see the patterns the leaves, lighting and tree bark create? Look at the different colors. If you can capture the patterns, you can draw the tree.

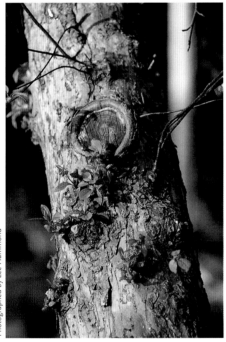

This is an interesting combination of colors and textures.

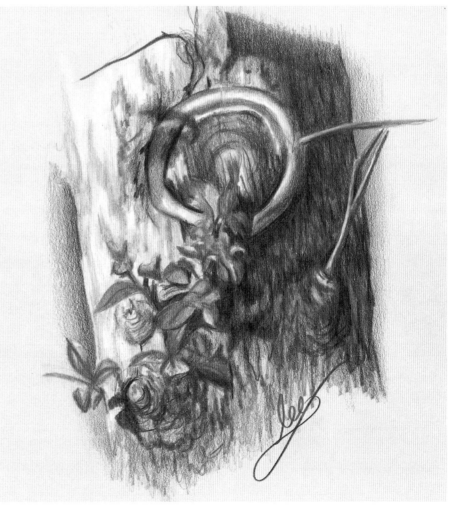

Tree bark can be created with loose vertical pencil lines. The lighting in this picture helps the light side of the tree stand out, giving it contrast.

KNOTHOLE
Verithin on no. 912 India mat board
10" x 8" (25cm x 20cm)

Drawing Details of Trees

Nature is full of interesting textures, shapes and surfaces. All of them present both challenges to and problems for the aspiring artist. Maybe I can take some of the mystery out of drawing some of them.

Let's begin with pine needles. Close observation will show you that they are made up of very quick tapered pencil strokes. The key to drawing them is to be sure to use layers of quick strokes that overlap. Don't make the strokes hard, deliberate or all the same length, like the small example.

This looks harsh and unnatural. The finished drawing looks better due to the many layers of pencil strokes. Can you see how the twig down the middle looks like needles are coming out from all around it, and not just out from the sides like the other example?

This drawing of an acorn is one of my favorites. Not only have I always loved the shape of acorns, with their little "hats," but I also love what they represent in the circle of life. To me it is always awe-inspiring to see the small acorn, with all of its potential, hanging among the branches of an already huge tree.

These acorns look very small compared to all of the leaves surrounding them. The combination of lights and darks makes this a pretty composition.

There are many other complicated textures out there and, unfortunately, not enough pages here to cover them all. Look around you and see what other challenges you can find to test your skills. The more you do, the better you will become!

Quick tapered strokes create the look of pine needles.

ACORNS
Verithin on no. 903 Soft Green mat board
13" x 10" (33cm x 25cm)

Fruits and Vegetables

There is an old saying about "saving the best for last." For this book, that saying may hold true. Every time I see the brilliant colors and shine of a piece of colorful fruit, my mouth waters—not because I want to eat it, but because I want to draw it!

You saw in some of the previous chapters how much fruit lends itself to the many different colored pencil techniques. Like flowers and plants, fruits have different surfaces and colors that make them perfect for discovering color. The following projects will give you a chance to see for yourself how much fun drawing fruits and vegetables can be.

This illustration of a pear was done in Verithin pencils. This was an interesting piece due to the many colors found on the skin of the pear. The smooth, yet speckled, surface meant working in layers.

First, I created the overall color of the pear *without* the speckles. I used various shades of yellow and brown. Once I was happy with the basic color

and the shape created by it, I added the speckled appearance on top with Tuscan Red. To make the whole thing look shiny, I added white.

The leaves were done much like the ones we looked at in chapter eleven, looking carefully for the veins and their direction. The background is nothing more than a subtle addition of True Blue used to accent the pear and make it stand out from the paper color.

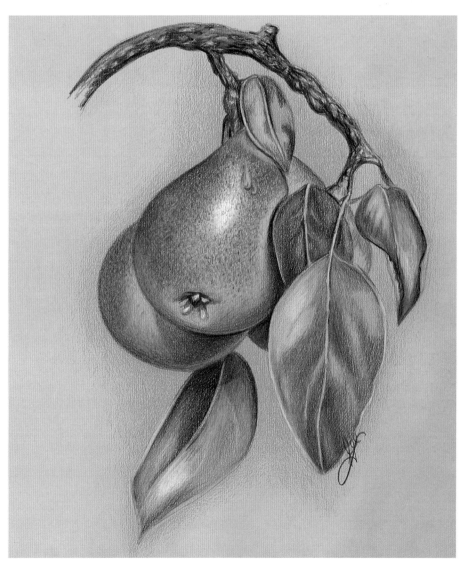

PEARS AND A LEAF
Verithin on no. 1026 Rose Gray mat board
10" x 8" (25cm x 20cm)

COLORS USED

Pears. Canary Yellow, Yellow Ochre, Dark Brown, Tuscan Red, Apple Green and White (the drip was created with Tuscan Red and White)

Leaves. Dark Green, Apple Green, Tuscan Red and White

Stem and branch. Dark Brown, Black, White and True Blue (reflecting from the background)

Background. True Blue

Drawing Strawberries and Bananas

Here are two more popular fruits for you to draw. The seeds and uneven surface make this simple strawberry a challenge to draw. Look at how the seeds are recessed, creating a craterlike surface. Both shadow and reflected light areas can be seen around them.

The black background around the strawberry makes the colors appear bright and vivid. An application of varnish completes the shiny appearance.

Displaying these bananas in the grapevine basket is like bringing the beauty of nature inside.

STRAWBERRY
Prismacolor on no. 901 Apricot mat board
4" x 4" (10cm x 10cm)

COLORS USED

Poppy Red, Crimson Red, Tuscan Red, Yellow Ochre, Apple Green, Dark Green, Black and White

BANANAS IN A BASKET
Prismacolor on no. 971 Daffodil mat board
10" x 8" (25cm x 20cm)

COLORS USED

Bananas. Canary Yellow, Yellow Ochre, Spanish Orange, Burnt Ochre, Yellow Chartreuse, Terra Cotta, Dark Brown, Black and White
Basket. Dark Brown, Terra Cotta, Burnt Ochre, Tuscan Red, Light Umber, Black and White
Tuscan Red is seen in the upper left corner, as are Ultramarine and Indigo Blue.

Drawing Artichokes

These artichokes were drawn with Verithin pencils. When drawing them, I was startled by their similarity to pinecones. Not only was the basic shape the same, but overlapping segments also create them.

I used a light layered approach to render the artichokes, using very few colors. The light green of the paper coming through helped create their color. It only required a few different colors of pencils to achieve this look.

I think the most important element of this drawing is the way the surfaces overlap, creating definite hard edges, as well as cast shadows.

There are subtle areas of reflected light on just about every leaf.

The sharp pencils that I used created the look of texture. Look closely and you will see how important the line direction was for giving it this appearance.

ARTICHOKES
Verithin on no. 903 Soft Green mat board
9" x 11" (23cm x 28cm)

COLORS USED

Olive Green, Yellow Ochre, Dark Brown, Dark Green, Tuscan Red and Black

Drawing Chili Peppers Step by Step

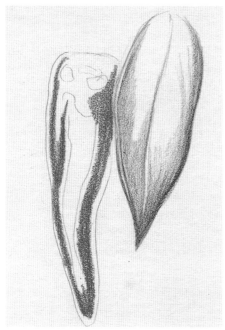

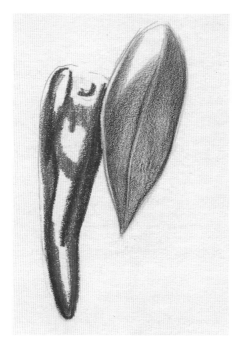

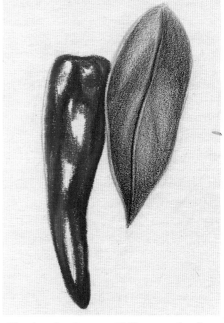

1 To begin the drawing, lightly sketch the pepper in pencil on no. 962 French Gray mat board. Be sure to establish where the White highlights will be.

With Poppy Red Prismacolor, start placing color into the pepper, inside the edge. With Dark Green Verithin, begin layering color into the leaf.

2 Continue with the pepper by adding Crimson Red next to the Poppy Red. Fill more Dark Green into the leaf.

3 Apply Canary Yellow to the far left edge of the pepper. Erase the graphite lines to prevent them from becoming dark and permanent. You will not be able to cover it up.

Use Tuscan Red Prismacolor to create the dark areas of the pepper. This creates the unique shape of this veggie.

Add Tuscan Red Verithin to the leaf to create the shadow areas and the vein. Leave a light area for the vein itself.

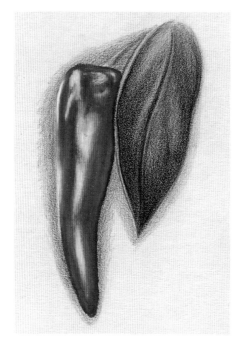

4 To finish the drawing, burnish over the highlight areas of the pepper with White. This makes the whole pepper look shiny and reflective. Add Peacock Green Verithin to the leaf to give it more color. Finish the drawing by adding a smooth layer of Dark Green around the pepper and leaf.

Drawing Water Drops Step by Step

Any flower, fruit or vegetable can look even more attractive by adding some water droplets. Look at the drawing of the pear. The moisture on its surface makes it look juicy enough to eat!

The following instructions show you how to draw water drops. Add them to your art to make your subjects gleam!

Don't be afraid of things that look complicated. Take it a small area at a time. Go slow. Do not confuse requiring time to complete with being difficult. The time invested is always worth it, especially when you finally reach the finish and can proudly display the beautiful work you have done. And remember to have fun!

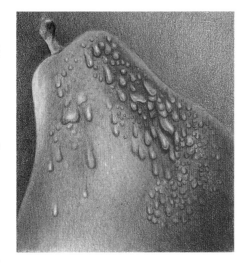

These water droplets are little sphere exercises. Although they are somewhat time-consuming to draw, they can give your fruit a fresh, realistic appearance.

PEAR
Verithin on no. 912 India mat board
6" x 6" (15cm x 15cm)

1 Begin with a round or teardrop shape. Use the darkest color of the surface you are drawing on. These drops would be found on something red, like an apple, a tomato or a plum.

2 Establish where the light would be coming from by outlining the highlight area.

3 Develop the shadow edge, keeping in mind the sphere exercises from page 21. Refer back to them if necessary. Using a lighter color, add tone to the shape.

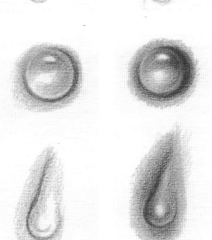

4 Build up the color, being sure to leave bright areas of highlight and reflected light. Place the surface color around the edge of the water droplet.

Water droplets can vary in shape, depending on if they are still or dripping. Study catalogs or grocery advertisements for pictures of fruits and vegetables and see how different each drop can look.

Drawing Apples Step by Step

The drawing was done with Prismacolor and then sprayed heavily with gloss damar varnish when completed. It almost has the look of oil paintings because of the varnish.

Follow the step-by-step procedures for drawing these apples using this technique.

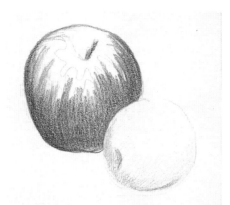

1 Lightly apply a layer of Carmine Red to the red apple. Apply a small amount of Tuscan Red and Yellow Chartreuse.

Apply Yellow Chartreuse and a small amount of Tuscan Red to the green apple.

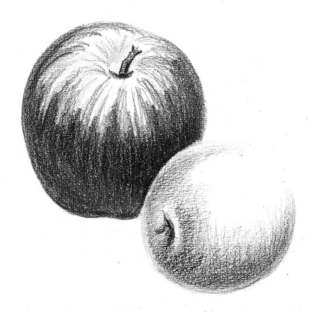

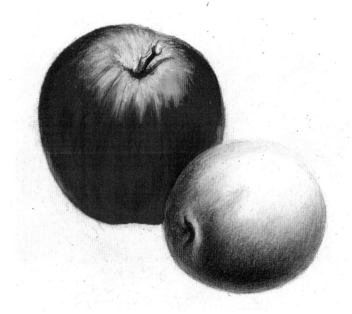

2 Apply heavier applications of the same colors to both apples. Use firmer pressure to begin the burnishing process.

3 With Carmine Red, firmly fill in the apple everywhere but the highlight area on top. Use White to burnish over the highlight area. Create the stem with Tuscan Red and White.

Burnish over the green apple with Yellow Chartreuse. Use White to burnish the highlight areas. Spray the finished drawing to prevent the wax from "blooming."

The red apples were drawn on a board with a surface that resembles the weave of linen cloth. I had to work very hard to fill in all of the texture, but the work was worth it. Gloss varnish was applied to the finished piece. This drawing looks as if it has been painted on canvas.

I hope you find the same enjoyment that I have in drawing the wonderful world around us. There is nothing more colorful and more beautiful than nature. It is where we can see the past, the present and the future all at once. Good luck to every one of you as you follow your artistic desires. I hope I have been some help in guiding you along your way!



COLORS USED

Apples. Carmine Red, Scarlet Red, Crimson Red, Tuscan Red, Black and White
Leaves. Olive Green, Grass Green, Apple Green, Tuscan Red, Black and White
Background. Black



RED APPLES
Prismacolor on Lin-coat board
6" x 8" (15cm x 20cm)

Index